The Principal's Guide to Afterschool Programs K–8

Extending Student Learning Opportunities

Anne Turnbaugh Lockwood

Foreword by Kent D. Peterson

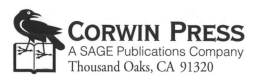

CORWIN PRESS
A SAGE Publications Company
Thousand Oaks, CA 91320

For information:

Corwin Press
A Sage Publications Company
2455 Teller Road
Thousand Oaks, California 91320
www.corwinpress.com

Sage Publications Ltd.
1 Oliver's Yard
55 City Road
London EC1Y 1SP
United Kingdom

Sage Publications India Pvt. Ltd.
B 1/I 1 Mohan Cooperative
 Industrial Area
Mathura Road, New Delhi 110 044
India

Sage Publications Asia-Pacific Pte. Ltd.
33 Pekin Street #02-01
Far East Square
Singapore 048763

Printed in the United States of America

Library of Congress Cataloging-in-Publication Data

Lockwood, Anne Turnbaugh.
The Principal's guide to afterschool programs, K–8: Extending student learning opportunities/Anne Turnbaugh Lockwood.
 p. cm.
Includes bibliographical references and index.
ISBN 978-1-4129-0441-4 (cloth)
ISBN 978-1-4129-0442-1 (pbk.)
 1. After-school programs—United States. 2. Student activities—United States.
I. Title.

LC34.4.L63 2008
371.19—dc22 2007007910

This book is printed on acid-free paper.

07 08 09 10 11 10 9 8 7 6 5 4 3 2 1

Acquisitions Editors:	Rachel Livsey and Lizzie Brenkus
Editorial Assistants:	Phyllis Cappello, Desirée Enayati, Ena Rosen
Production Editors:	Beth Bernstein and Diane S. Foster
Copy Editor:	Brenda Weight
Typesetter:	C&M Digitals (P) Ltd.
Proofreader:	Caryne Brown
Indexer:	Molly Hall
Cover Designer:	Lisa Miller

The
Principal's
Guide
to
Afterschool
Programs
K–8

To my father, Roy C. Turnbaugh,
a good and faithful servant in the
cause of public education
1921–2005

Contents

List of Tables

Foreword

This book provides a widely useful compilation of ideas, cases, innovative approaches, and practical strategies for enhancing a little-discussed school activity—afterschool programs. By taking a new look at these ubiquitous programs, Anne Turnbaugh Lockwood identifies a substantial resource in the effort to increase student learning. In this book she provides an enormously useful range of strategies for designing, implementing, and evaluating afterschool programs.

This work would be an important resource if it only highlighted the ways afterschool programs could enrich their missions by establishing academics as a more central part of their work. But the book goes well beyond just making us aware of this seemingly underutilized learning setting. It covers and describes all the major factors in building successful afterschool programs that enhance achievement.

This volume is an important resource for school principals, agencies that provide afterschool programs, districts, and parent groups whose children use these services. First, it provides a new perspective on afterschool programs, showing how they can be an important source for both recreation and academic learning. Afterschool programs are found all across the United States serving millions of students. Understanding how they can more effectively serve the learning needs of students adds a major cache of time for helping all students achieve. Second, the book provides a relevant and constructive set of strategies and ideas for making these programs effective. Numerous research studies, Internet Web sites, and publications extend these ideas.

This book should be read by anyone who views afterschool programs as an additional way to help students learn, because it offers a wide set of practical ideas for designing, implementing, and evaluating these programs. All the key processes necessary for changing an existing or implementing a new program are found in this volume.

Any leader who wants to develop effective afterschool programs that foster student learning will gain much from this book. For example, the reader is offered concrete examples of effective programs through case studies of existing afterschool efforts. These cases show what a good program looks like, how it is run, and key features. In addition, the book lays out practical steps for planning programs, hiring staff, designing curriculum, selecting activities, and providing professional development. In another section, Lockwood lists an important set of issues to consider when designing an afterschool program and then adds an inventory of important questions to consider. She describes barriers to success and then presents suggestions for overcoming those barriers. Throughout the book, Lockwood sets out to make the material accessible to readers interested in implementing these programs—these ideas are found in the form of questions and suggestions, tables of issues to address, and practical strategies to consider. The tables and strategies themselves are worth the price of the book.

This book also examines several other issues that often spell the end of quality programs—developing a parent and community base of support, designing adequate program evaluation processes, and planning for sustainability. One finds a useful set of questions, ideas, and strategies for building a base of support among parents and the community. The section on program evaluation is quite practical and detailed. It offers a clear description of ways schools can and should evaluate afterschool programs. Finally, the chapter on sustainability details challenges to the viability of afterschool programs and suggests actions schools should take to ensure that these programs are successful in the long term.

Overall, this book offers a variety of school and community leaders a concrete, useful, and in-depth look at ways to design, implement, and evaluate a major resource in the learning of students. Clearly written, well organized, and enormously practical, it should be in every school's professional library.

<div align="right">
Kent D. Peterson
Department of Educational Administration and Policy
University of Wisconsin–Madison
</div>

Preface

A recent article in *Education Week* stated, "the push for higher academic standards and student achievement is now extending beyond the school day, fueling a growing demand for high-quality after-school programs" (Manzo, 2006). That is the central thesis of this book, a work that began in 2001 with a study of superintendents and their leadership of effective afterschool programs and grew into the present book.

From 2001 to 2003, as the issues analysis director at the American Association of School Administrators, I worked on a grant from the Charles Stewart Mott Foundation to study how school superintendents could exert strong leadership to overcome common district-level bureaucratic barriers to effective afterschool programs (Lockwood, 2003a, 2003b). After coming to the Northwest Regional Educational Laboratory as a senior program advisor, I continued research on leadership and afterschool programs but shifted emphasis to focus on school principals and their connection to heightened student proficiency levels. Specifically, I was interested in how principals in K–8 schools could help increase learning in the afterschool hours.

This book revolves around the key question that developed from the second phase of my research: In what ways can principal leaders maximize student academic proficiency through afterschool programs—particularly for students most at risk of academic failure? Five main reasons prompted this question:

1. The principal's singular opportunity to improve or enact a high-quality afterschool program with an academic focus—extending the regular school day with the intent of boosting student proficiency levels

2. The growing national emphasis, stemming from the accountability requirements of the No Child Left Behind (NCLB) Act,

on academic achievement as an integral and previously untapped part of afterschool programs

3. The changes in accountability that principals now confront in the wake of NCLB

4. The progressively severe sanctions principals in low-performing Title I schools must confront if their students do not meet the requirements of Adequate Yearly Progress

5. The presence of many, if not most, afterschool programs in Title I schools serving large percentages of high-poverty, minority students at risk of academic failure

The opportunity to mark progress is almost boundless, but challenges are multiple. As with anyone at the beginning of a road trip, it is good to have a map and a plan in your hands that will help you surmount barriers to success. The demands are so many, and include the following:

1. Involving the entire school improvement team in a strategy to use the afterschool hours seamlessly from the regular school day in a way that integrates the district's academic and curriculum standards, aligned with those of your state

2. Building a communications two-way plan with parents and other stakeholders that enlists them into the drive for heightened academic proficiency in the afterschool program their children attend

3. Devising a set of goals for engaged teaching and learning in tandem with your staff

4. Ensuring that curriculum and instruction in the afterschool program will be carefully planned, executed, and monitored

5. Designing evaluation of the program's outcomes so that the results of the evaluation are reliable, cost-efficient, and easy to administer.

The purpose of this book is to guide the principal through the process of either changing an existing afterschool program to one that includes a solid academics component, or creating an afterschool program with a substantive focus on achievement. It includes sections on setting up the program, overcoming potential barriers to success,

appropriate goal setting, implementing and operating the program, case studies of successful principals, devising an evaluation plan for your program, and a discussion of sustainability.

Any opinions, findings, or recommendations are those of the author alone and do not necessarily reflect the views of the Northwest Regional Educational Laboratory or the American Association of School Administrators.

Acknowledgments

Writing any book is a collaborative endeavor. This one has been marked by unusual generosity. In particular, I would like to thank Dr. Carol F. Thomas and Dr. Robert E. Blum of the Northwest Regional Educational Laboratory (NWREL), respectively, for their ongoing, generous support of the development of this manuscript and their commitment to this topic.

Original research conducted at the American Association of School Administrators in Washington, D.C., under the auspices of the Charles Stewart Mott Foundation folded into the present book. I am grateful to the Association for the opportunity to work on the national project, to each district that collaborated in the study, and to each staff member—from superintendents to business office personnel—who related their experiences with afterschool programs within the wider context of districts and the more focused context of individual schools. Their comments added greatly to this book.

This manuscript was informed by many insightful comments from Dr. Eve McDermott of NWREL's Center for School, Family, and Community. I appreciate her willingness to review the manuscript as well as her ongoing interest in this project.

Dr. Steven R. Nelson, administrator of NWREL's Office of Planning and Service Coordination, gave generously of his time, his expertise, and his knowledge.

My long-time colleague, Kent D. Peterson, Professor of Educational Administration and Policy Studies at the University of Wisconsin, is and has been my sounding board on issues related to leadership for many years. His knowledge of the principalship is all-encompassing, and I appreciate his scholarship coupled with his practical wisdom.

Finally, I want to thank the staff at Corwin Press for their expertise and support, particularly Rachel Livsey, who was steadfast in her belief that this is a topic worth adding to the educational literature. I appreciate her commitment to this book.

I extend my thanks also to the fine staff at Corwin Press who sheparded this book through production.

Corwin Press gratefully acknowledges the contributions of the following reviewers:

Michele R. Dean
Principal
Montalvo Elementary School
Ventura Unified School District
Ventura, CA

Georgia Hall
Research Scientist
National Institute on Out-of–School Time
Wellesley College
Wellesley, MA

John C. Hughes
Principal
Public School 48
Bronx, NY

Catherine H. Payne
Principal
W. R. Farrington High School
Honolulu, HI

Paul Young
Executive Director
West After School Center, Inc.
Lancaster, OH

About the Author

 Anne Turnbaugh Lockwood is Senior Program Advisor in the Office of Planning and Service Coordination at the Northwest Regional Educational Laboratory in Portland, Oregon. A policy analyst, she has worked in settings that range from the Wisconsin Center for Education Research at the University of Wisconsin–Madison; to her own consulting business; to the American Association of School Administrators in Washington, D.C.; and to the Northwest Regional Educational Laboratory in Portland, Oregon. She is the author of seven books and over 100 articles on a wide variety of educational issues. She is a recipient of the Interpretive Scholarship Award of the American Educational Research Association, given for writing that connects research to practice. She has been an Honorary Fellow in the Department of Curriculum and Instruction and in the Wisconsin Center for Education Research, both at the University of Wisconsin–Madison. She holds a PhD in Educational Psychology from the University of Illinois at Urbana–Champaign.

1

Why Afterschool Programs Are Necessary

We knew we had to do something about students' academic performance in our district—and we knew the time permitted within the regular day was just not enough. We decided to turn to our principals and have them concentrate on our out-of-school hours as an extension of the regular day—but constructed slightly differently. This meant a whole new orientation toward those hours. Results were amazing. In a relatively short period of time, our entire staff galvanized around the program and considered it a part of the regular day, the children enjoyed it, and parents appreciated the results. Our principals were proud. Staff and students benefited, and the community reaped the rewards.

> —A superintendent in a small town in the Midwest
> with a growing number of English language learners

I was worried about my son's attitude toward school. He didn't enjoy it. He didn't feel he had a place there. His grades and test scores were low. I didn't see how an afterschool program would help. We had one, but my son mostly played basketball. But this program worked. Mrs. Calamasta (the

principal) involved the whole school team, and the entire
day became better. Joe (my son) didn't lie to me anymore
about whether he went to school and participated. Pretty
soon he would come home and tell me about his day. And his
day included the hours he spent in the afterschool program.
Next year I'm going to volunteer.

—Mrs. Madsen, the mother of a fourth
grader in a large city on the East Coast

Principals who want to raise student proficiency levels, particu-
larly in high-needs schools, see the necessity to change their
afterschool programs. This is not completely dominated by princi-
pals' realization of the new high-stakes accountability within which
they work—although it is a consideration. As building leaders of
school reform efforts, principals continually seek ways to extend
student learning opportunities. Somehow, there is never enough time
in the regular day to fully serve high-needs students.

As a consequence, principals are beginning to think in new ways
about that extends student learning beyond the school day that can
occur in seamless ways. While they want their programs to have a
much more concentrated focus on academics, they realize—along
with parents, afterschool leaders, and members of the community—
that programs also must permit opportunities for students to partici-
pate in activities and just have fun. While principals want to set up
the programs so that the academic component is engaging, they also
realize that students need to let off steam after the regular day.

Who can argue against afterschool programs? Principals, with an
overwhelming degree of consensus, agree that afterschool programs
are a good idea (National Association of Elementary School Principals,
2005). At minimum, parents know where their children are after school
if they attend the program—supervised, safe, and sheltered. Tradi-
tional programs, at best and when properly implemented, offer enjoy-
able activities that yield a high degree of interaction with supportive
adults and staff at community agencies, leading to enriched daily expe-
riences for high-needs students. These experiences usually revolve
around recreation, some homework help, a snack, and afterschool care
until parents can pick up children or they can be bused home.

But afterschool programs have the potential to be much more. They
can incorporate a strong focus on academics in addition to providing

students with experiences they would not have in their daily lives (such as field trips, museum visits, or special projects). Principals who want to lead reform efforts see this possibility and realize that the ever-rising bar of student proficiency levels under the reauthorization of the Elementary and Secondary Education Act (ESEA), known as the No Child Left Behind Act (NCLB), means that they need to be creative to help low-performing students achieve academic proficiency.

As Fashola (2002) pointed out in her review of effective after-school programs, these two approaches to afterschool programs (e.g., safety, child care, and recreation versus afterschool programs with an academic focus)—splinter into two very different viewpoints on afterschool programs.

Principals and Afterschool Programs

Why are afterschool programs relevant to principals? There are several reasons:

- Afterschool programs are housed in principals' buildings.
- Afterschool programs are a part of the principal's leadership domain and can be considered an integral part of the school improvement plan.
- Afterschool programs offer low-performing students a targeted way to spend more time in a particular content area, taught in an enriching and engaging way.
- Afterschool programs, when well constructed, can help ward off the possibility of supplemental educational services (necessary if a school slips into "schools in need of improvement" [SINI] status for three consecutive years).
- A sound afterschool program, if a school does fall into three consecutive years of SINI status, can become the foundation for in-school supplemental services—preferable to students going out of the school to for-profit firms for tutoring services.
- Viewing the afterschool program as part of a seamless school day helps ensure that high-needs students can receive more attention and more time engaged with learning.

The Opportunity and the Mandate

Principals understand the seismic change that has shaken public schools. The NCLB Act mandates that 100 percent of students reach

proficiency by the school year 2013–2014. This is not rhetoric: it is the law. Sanctions follow if schools do not meet the annual requirements of Adequate Yearly Progress (AYP).

The thesis of this book is that afterschool programs, when well constructed, when built in bold new ways that avoid the pitfalls of tradition and the perils of unrealistic hopes, offer considerable promise for helping to raise the proficiency levels of high-needs students. And clearly, any principal has a moral and ethical obligation to his or her students to seize every responsible opportunity to advance the students where there are critical areas of need.

Aside from the requirements of ESEA, there are increasing arguments that extended learning time in schools increases both "time and support" for low-achieving students (Pennington, 2006). One recent report goes so far as to advocate state policy that mandates an extended day, rather than afterschool programs that are voluntary. Although the report focuses on high schools and this book centers on K–8 schools, its recommendations that (a) public policy play a weightier role in extended learning time for high-needs students and (b) a seamless school day has the potential to boost student proficiency levels are additional compelling contentions in favor of afterschool programs with a more robust emphasis on academic achievement.

But now, back to NCLB. Since the bar of AYP requirements is continually raised, no principal can rest easily just because his or her school meets AYP requirements for one year. There is the next year of testing, and the next. Meanwhile, the school population swells, and demographics change. Add to those variables the population of transient students—an additional barrier to adequate measurement.

All of these factors affect student performance on state tests. The old saying "too much is not enough" applies to the ever-increasing responsibilities principals and instructional staff confront. What may seem like too much planning, too much intervention, and too much professional development for one year will most certainly not be sufficient for the next.

Later in this chapter, I will discuss the polling data that support the fact that segments of the public, particularly minority and low-income parents, want an academic component in their afterschool programs. They realize their children need more time with academic material in order to succeed. I also will present the five goals of accountability principals must address when they work with staff to construct a new afterschool program or change an existing program to include an academic focus.

Proponents of increased academics in afterschool programs believe that when properly conceived, a strong academic component

in afterschool programs offers students more time on task and an opportunity to boost sagging proficiency levels, or at minimum the ability to hold their proficiency levels constant, as well as a means of bolstering more adult-student interaction in academics than is usually offered in the regular classroom due to size.

The New High-Stakes Climate: Building a Basis of Support

Unquestionably, the NCLB Act, signed into law in 2002 as the reauthorization of the ESEA, brought a new climate of accountability to the nation's public schools. Nationwide, both veteran and new principals work to implement NCLB's provisions. New principals in particular are thrown into cold water when their knowledge of NCLB's accountability requirements begins to permeate the reality in which they work.

Meeting the needs of all students—particularly in Title I schools that are subject to sanctions if AYP requirements are not met—can be an overwhelming task. Suddenly, all principals confront how high the stakes actually are for their schools—and how widely information about student academic performance is disseminated and used to hold schools accountable. This makes their work transparent to all stakeholders. Every effort is visible. Every success is seen—and every failure can be scrutinized. And while school leaders may agree philosophically with the goals of NCLB, implementing those goals can be a difficult task.

How states determine AYP requirements remains what one data analyst calls "a moving target." Pity the poor swimmer who has not mastered the basics, does not realize she has leaped off the pier into progressively deeper water, and is perilously close to drowning.

Under NCLB, prior to 2013–2014, states have set intermediate targets for schools to meet through the requirements of AYP. These intermediate targets, or goals, increase incrementally. According to Title I, Part 200.17, these increments were supposed to occur first in the 2004–2005 school year, with each increment following in not more than three years.

An annual testing program of all students in all subgroups, Grades 3–8, in reading and mathematics is mandatory (although there are exceptions, depending on numbers in subgroups). Data obtained through these state assessments are disaggregated by the student's socioeconomic status, disability status, English language learner status, race, ethnicity, gender, and migrant status. To ensure fairness, the state must ensure that its measurable objectives are uniform throughout the state (Title I, Section 200.18).

If one student subgroup fails to meet AYP, the entire school fails, and students can end up in "AYP jail" if the school continues to fall short of the AYP mark. This translates to progressively stricter sanctions for Title I schools labeled in need of improvement (SINI), which occurs if they fail to meet AYP requirements for two consecutive years (Title 1, Section 200.32). At this point, students in the SINI school are eligible first for public school choice, and then, in the third year of SINI status, supplemental educational services are provided for those students who choose to remain in the school, at no cost to the student or parent.

If a school identified as in need of improvement continues on the SINI list, sanctions increase. In addition to the choice and supplemental services provisions, corrective action applies.

Additional corrective actions can include

- replacing school staff considered integral to the school's failure to meet AYP,
- instituting a new curriculum (including professional development to accompany the curriculum),
- decreasing management authority at the school level,
- appointing outside experts to advise the school,
- extending the length of the school year or day, and/or
- restructuring the internal organization of the school (Title I, Section 200.39).

What is meant by "supplemental educational services," to date, is unclear to many states, districts, and schools. In fact, they are a bramble patch of nonregulatory guidance, private providers competing with nonprofit providers, and district and building-level leaders struggling with their provisions—all mired in a welter of good intentions.

Yet supplemental educational services offer the potential to improve student achievement during the afterschool hours and should be considered carefully in terms of their potential to lift student proficiency levels as the principal plans ahead—in the event that the school remains in the "in need of improvement" category by the third year.

Increasing Enrollments

But the current provisions of NCLB are not the principal's only challenge. An additional complication is presented by the increasing

enrollments projected from 2005 to 2014 (National Center for Education Statistics, 2006). According to the National Association of Elementary School Principals (2005), near-record levels of elementary students were enrolled in the fall of 2005, which included 33.5 million students in public schools and 4.9 million in private schools. Elementary school enrollment rose 14 percent between 1990 and 2001 and was followed by a hiatus or slight decline, depending on geographical area, between 2001 and 2005 (National Association of Elementary School Principals, 2005). But by 2014, an additional 2.2 million elementary school students are projected to enroll in public schools, a 6 percent increase from 2005. The states expected to experience the highest rises in elementary school enrollment are Nevada, Utah, Texas, Idaho, and California, at over 15 percent between 2005 and 2014.

Undoubtedly, these increasing enrollments will reflect increasing diversity as well as burgeoning numbers of special education students. Both of these factors will have a huge impact on the student subgroups in the school and whether the school will be able to reach AYP requirements.

In addition, Title I schools have the largest number of afterschool programs. Nationwide, Title I schools currently number approximately 50,542 as compared to non-Title I schools at 42,289. This figure includes elementary, middle, and high schools—important to remember since the majority of afterschool programs are housed in elementary schools. Title I *elementary* schools nationwide number approximately 34,668 compared to 14,439 non-Title I schools. Obviously, Title I schools are a hefty proportion of elementary schools and therefore can be expected to have the most afterschool programs that can be tailored to the accountability provisions of NCLB.

What implications do growing enrollments have for students' proficiency levels? As enrollments increase, particularly in Title I schools, principals can expect that the number of students who meet AYP requirements will decrease.

21st Century Community Learning Centers and Academics

The 21st Century Community Learning Centers (21st CCLCs) are a strong federal program that has now shifted to the states. Established in 1994, the 21st CCLCs have funded many, if not most, afterschool programs in high-needs schools nationwide. The original program

goal of the 21st CCLCs did not change until 2001 under NCLB, when it stated the following:

> The 21st CCLC Program is a key component of President Bush's No Child Left Behind Act. . . . The focus of this program, re-authorized under Title IV, Part B, of the No Child Left Behind Act, is to provide expanded academic enrichment opportunities for children attending low-performing schools. Tutorial services and academic enrichment activities are designed to help students meet local and state academic standards in subjects such as reading and math. In addition, 21st CCLC programs provide youth development activities, drug and violence prevention programs, technology education programs, art, music and recreation programs, counseling and character education to enhance the academic component of the program. (U.S. Department of Education, 2002)

In a strongly worded statement by then–Deputy Education Secretary Hansen, the 21st CCLCs were criticized for their effectiveness. This resulted from a largely unfavorable longitudinal evaluation commissioned by the U.S. Department of Education by Mathematica Policy Research, Inc., that will be discussed in Chapter 6. Hansen went so far as to suggest that the 21st CCLCs receive a drastic cut in funding in the President's 2004 budget.

Hansen stated that the findings supported a need for program changes. Specifically, he argued that afterschool programs should have a new and stronger focus on the following:

- Content. Programs should result in improved academic achievement.
- Behavior.
- Safety.
- Participation. The findings of the evaluation revealed that student participation was low. (U.S. Department of Education, 2003)

The definition of community learning centers supported all of Hansen's contentions, which were made in the context of President George W. Bush's 2004 budget.

The term *community learning center* means an entity that assists students in meeting state and local academic achievement standards in core academic subjects, such as reading and mathematics, by providing the students with opportunities for academic enrichment

activities and a broad array of other activities during nonschool hours or periods when school is not in session (such as before and after school or during summer recess). These activities reinforce and complement the regular academic programs of the schools attended by the students served. In addition, literacy and related educational development services are offered to families of participating students (U.S. Department of Education, n.d.a.).

Has this been borne out? Many afterschool advocates would argue that it has—pointing to the 21st CCLC evaluations the state requires. But a reality test—the principal's own observation of the academic content of the afterschool program coupled with the achievement of high-needs students in the school—usually suggests that more strategic action needs to be taken. And making the transition to an afterschool program that has a keen focus on academics means that the principal—in tandem with the school improvement team—must build a web of support within the community, with parents, with staff, and with existing afterschool programmatic staff to ensure that the new direction will be endorsed.

Changing or Creating a New Program

Principals probably already realize that afterschool programs, as they currently exist, are well liked in communities. Although the goals of the 21st CCLCs, in particular, have shifted toward including a stronger emphasis on academics, there are still many afterschool advocates and agencies who see little reason to change current practice. In fact, they fear that students will be overly taxed if an emphasis is placed on academics in out-of-school hours, leaving them tired and subject to the "drill and kill" syndrome.

But this assumes that instruction in afterschool programs will be poorly handled. It also assumes that the principal will abdicate responsibility to a staff not aligned with the regular school day's instructional mission that has been designed to *engage* students—a clear mistake and one not connected to overall school improvement efforts. And it presupposes that youth enrichment, youth development, and project-based learning will be discarded.

Engaged Learning Time

Instruction needs to be connected to that offered during the regular school day so that students can continue to learn. However, the ways

in which instruction is offered can be project based, activity based, or built around a high-quality set of commercially produced curriculum materials. Learning experiences need to be authentic. And the critical factor is that instructional time—whether it is time during the regular school day or after school—needs to be *engaged learning time* (Newmann & Associates, 1996).

It can be difficult to find a precise definition of *engaged learning time*, since *engagement* has entered the educational vernacular to an extent that, at times, has gutted its meaning. Fred M. Newmann and his colleagues at the University of Wisconsin–Madison developed the concept in the mid- to late-1980s and define it as follows in a summary publication of their work authored in the early 1990s: "the student's psychological investment in and effort directed toward learning" (Newmann, 1992, pp. 12–13).

This definition of Newmanns and his colleagues contains interesting statements. Chief among them is the clear delineation between the ability to get high grades and complete tasks versus a psychological investment in learning or comprehending new skills. Another point that often eludes educators is the necessity to view engagement on a continuum of less to more, not as a dichotomy of "engaged" or "disengaged." This provides principals and afterschool staff an excellent lens to view the program. Are students more engaged with some learning activities than others? What could be some reasons for this? If they are less engaged with other learning activities, what might be some reasons? How might these be ameliorated? If students are totally disengaged, should the learning activity be completely discarded?

Drawing Upon Existing Support and Building a New Base

One strength principals can draw upon when changing the direction of a current program is the support of school staff, parents, school board members, and community members. They need to build this support as part of their overall school improvement plan, but if the proposed change is well presented, success is likely.

Proponents of increased academics following the regular school day need to be specific about what will be taught in the afterschool program, how the content will be taught, and the ultimate goal of this approach. This specificity should emphasize the fact that student learning will be engaging and approached in ways that will not prove overly

taxing to students. Even if the program does not result in dramatically altered academic achievement, it should have some effect and, one would hope, a cumulative effect if the student remains in the program.

When advocating this point of view, principals can easily point out that academics do not need to compose the entire afterschool program, that staff will respect the developmental needs of the child (as they should), and that project-based learning is a way for children to increase their academic proficiency (and can be and is used during the regular school day).

Certainly, principals can draw support from the 2003 programmatic goal of the U.S. Department of Education because it is much more closely tied to the realities within which they work under NCLB. Although a robust, even-handed research base is needed that can show the academic effectiveness of afterschool programs, principals can pioneer in the effort to harness all available resources toward this purpose.

I will discuss evaluation of afterschool programs in Chapter 5, but it is worth noting here that the last achievement gains reported for the 21st CCLCs were in 2002, and they reveal many of the problems in evaluating academic achievement. Evaluations of afterschool programs abound and vary in quality (e.g., Afterschool Alliance; Harvard Family Evaluation Project; Mathematica Policy Research, Inc.; RAND Corporation), but most to date have not focused on academic achievement or they present findings tilted by advocacy. Existing evaluations primarily focus on other outcomes of afterschool programs, such as safety.

Making a Case for Academics

As a result, we have only a slim and emerging research base that points to improved academic achievement in afterschool programs. But there are reasons for this:

- Afterschool programs, as pointed out, have not historically included a strong emphasis on academic achievement, thus making it difficult to evaluate their success in that area.
- Student attendance may be sporadic, presenting yet another difficulty for educators.
- Instruction (where it exists) typically is not aligned with the instructional program of the regular school day.
- Most afterschool staff are not prepared adequately for a focus on academic achievement since their expertise lies in other areas.

- Afterschool staff have not kept (or been directed to keep) a database that extends beyond "soft" variables such as attendance, self-reports, and surveys of parents.

Changing the Status Quo

The first steps to changing the focus of the existing afterschool program or creating a new program with an academic emphasis are straightforward—the "five R's":

Recognize and build upon the climate of accountability in which you work that has been created by the provisions of NCLB.

Realize that afterschool programs have the possibility to provide a venue to boost student proficiency levels, particularly in low-performing schools with large numbers of low-income, high-needs students.

Remember that afterschool programs are going through a painful transition from their original goals to a new goal.

Relate the new academic emphasis of your afterschool program in a two-way communications strategy to your school's instructional staff, the central office, the school board, parents, community agencies, and all other educational stakeholders to ensure maximum buy-in to the changing emphasis.

Review the ways in which your program has been successful or problematic; use that information to shape your new program emphasis.

The five R's of changing or creating the afterschool program present new work for building leaders. If in the past the program has been delegated to others or allowed to operate *de facto* in the school, it is understandable. The regular school day is all-consuming. Frankly, principals have plenty of other work to do—work related to overall school improvement, school management, dealing with parents, supervising instructional staff, making curricular decisions, managing personnel, and communicating with the central office. The value of afterschool programs can be seen in the abstract, but principals may believe—with considerable justification—that they are one more task that has landed on their desks. After all, doesn't the afterschool coordinator or director have the expertise to handle the program?

But if the program is strengthened *to include a substantive focus on achievement,* the principal realizes that afterschool directors and their staffs may or may not have the credentials that equip them for the task. They might not be accustomed to the school bureaucracy—or may be very skilled at negotiating its problematic areas. Much is dependent on their skills, acumen, and goals.

But if their goals are not aligned with the *principal's* goals, with the goals of the central office, with those of the instructional staff, and with those of the money that funds the program (usually in the form of a grant), only difficulties and snags will result, with the potential of jettisoning the afterschool program. If the program is funded by a grant, it may limp along for the duration of the grant, as staff come and go, and never achieve its desired outcomes.

Principals may, in fact, say that the program is "more trouble than it's worth." They may add that they are aligned with the philosophy of the afterschool program, but now that they know what is involved (for example, ongoing tension between instructional staff and afterschool program staff), they could easily forgo the presence of the program in their buildings. They may even feel some bitterness that the school seems like nothing more than a glorified babysitting service for working parents.

For the afterschool program to become much more tightly connected to the instructional component of the school day, particularly for those students who are particularly at risk of academic failure, the principal needs to exert instructional leadership that includes the afterschool program in a two-way communications program. This leadership ensures that the school's regular instructional staff, the afterschool director, and the afterschool staff are tightly connected with common goals. It also means that the afterschool director and staff must have background in (a) dealing with the school bureaucracy; (b) at least one important content area (reading, mathematics, English language acquisition); (c) knowing how to engage students in content area in ways that are active and fun and that will encourage their continued attendance; and (d) being sensitive to issues of youth development.

Obviously, this ratchets up the principal's responsibilities and workload. But if the afterschool program can be viewed as nothing less than part of the school day, rather than as an add-on with mixed goals that can range from drug and violence prevention to sports involvement to community service, an integrated approach to school improvement and boosted student proficiency levels can be reached.

Public and Student Expectations From Afterschool Time

To change the program and tie it more closely to academics, principals need some objective support. To what extent do peers and the public believe afterschool programs should contain an academic component—or emphasize academics?

The results of a 2003 MetLife poll of principals, teachers, and parents underscore the importance of academic achievement.

Principals' priorities ranked "motivation of students and faculty to achieve" at an overwhelming 75 percent (MetLife, 2003, p. 31), followed by "school morale" at only 45 percent—a difference of 30 percentage points.

A 2004 Public Agenda poll of parents' and students' views of afterschool programs, commissioned by the Wallace Foundation, found interesting results according to parental income levels and race. An emphasis on academics was most valued among low-income and minority parents. These are the parents whose children are the most likely to be served by afterschool programs, which are usually located in high-needs schools.

By marked percentages, *low-income and minority parents* favored programs that emphasized academics. This is not startling if one considers that higher-income parents are more likely to provide out-of-school academic support themselves, either directly or through tutoring, classes, or other activities and lessons.

The poll's findings included the following:

- Their child needs extra help in school (low vs. higher income: 67% vs. 44%; minority vs. white: 61% vs. 45%).
- An afterschool program that provides supervised homework time is something they would go out of their way to find (low vs. higher income: 52% vs. 28%; minority vs. white: 56% vs. 27%).
- Since schools are placing so much emphasis on standardized tests and higher academic standards, students are better off in afterschool programs that focus on academics rather than on other things (low vs. higher income: 45% vs. 35%; minority vs. white: 55% vs. 33%).
- They would be interested in a summer program that helped students keep up with schoolwork or prepare for the next grade (low vs. higher income: 69% vs. 51%; minority vs. white: 79% vs. 49%).

- They would "very much" like an afterschool program that focuses mainly on academic preparation (low vs. higher income: 39% vs. 24%; minority vs. white: 45% vs. 29%) (Public Agenda, 2004).

Low-income and minority students also resonate with afterschool programs and activities, the Public Agenda poll discovered, that feature learning:

- They would be more interested in a summer program that helped . . . keep up with schoolwork or prepare for the next grade (low vs. higher income: 69% vs. 51%; minority vs. white: 79% vs. 49%).
- They would "very much" like an afterschool program that focuses mainly on academic preparation (low vs. higher income: 39% vs. 24%; minority vs. white: 45% vs. 23%) (Public Agenda, 2004).

These polling results of principals, parents, and students support the growing movement among principals to use hours beyond the school day in astute ways that do not tax the child but that support and extend learning that occurs during the school day. Using these hours productively and in ways that do not burn out students who have already participated in a full day of academic work is the principal's challenge as well as that of the afterschool program's staff.

A central office administrator who coaches principals on leadership and their afterschool programs reiterated the challenge when she told me the following:

We are really in an age of accountability. Accountability has frightened some of our administrators and caused them to slow down their thinking outside the box. If the conditions aren't nurturing in a school community, doing what's right for kids, staying attuned with research and reform—it's easy to do whatever you've done in the past and call it good. That's the safer course to chart. But it isn't the real world. As I think about those schools which are doing what was successful 10 years ago, I'm very suspicious about what their success rate will be in the near future, even today for that matter. (Lockwood, 2003a)

Despite this administrator's cautionary and somewhat dark words about the "age of accountability," there are many school

leaders who have found ways to successfully rise to its challenges. Three profiles of success—selected for their specific efforts to incorporate afterschool programs into the regular school day—are presented in Chapter 4.

In Chapter 2, I move to the principal's first steps as he or she constructs or changes the existing program.

2

Building Your Afterschool Program

In one school district I visited, the neighborhood contained a sizable homeless population. The afterschool program enrolled a large number of homeless children for fairly long periods of time, until families could move on into more stable environments. The principal viewed this time with a high-needs population as a series of highly "teachable moments." While many principals might dismiss this student population because of their high mobility, this principal and his staff did not, concerting efforts to increase their proficiency levels whenever possible through creative means.

One way, the principal and his staff decided, was to integrate the population thoroughly with the rest of the school—which was an overall high-needs school in an impoverished neighborhood. The principal set up a monthly dinner for parents, students, and staff. While originally conceived for the homeless population, the principal and staff quickly saw the benefits to the entire school.

Through this monthly dinner, parents and students who had felt estranged from teaching and learning grew to know staff in a casual environment along with their own families. This built trust and helped families bond with school personnel. Student accomplishments were featured at the dinners. This social time also became an opportunity to talk informally about the afterschool program and student progress toward academic goals. Because nearly everyone in the school participated, the principal and staff avoided any sense of condescension toward a particular population—in this case, the homeless students.

> This principal considered this interaction a key component that kept students interested in and enrolled in the program. It also helped secure parent volunteers for the afterschool program.

What a wonderful example. And think of the steps it took to get there. Theodore Sizer, the leader of the Coalition for Essential Schools, once remarked to me in jest, "Someone has to call the meeting" (Lockwood, 1997). Principals call the meetings, but they also have a plan for their school improvement teams. This means they exert leadership over a relatively rapid but high-quality course of action.

Leadership for afterschool programs is not very different from the type of leadership you are familiar with on a daily basis. The same basic principles apply. However, changing the leadership focus of afterschool programs to the principal, rather than the afterschool director, is much easier when you have initiated and followed the first steps outlined previously. It is essential that the principal have a collaborative leadership style, rather than one that is outmoded and didactic.

The typical afterschool program has a different leadership construct. This underscores the need for initial efforts to be soft-pedaled and collaborative, yet firm and purposeful. The best way to do this is through regular, well-focused meetings of the school improvement team.

There are relatively simple ways for principals to change the leadership construct. Traditionally, afterschool programs have been delegated to their own directors or coordinators, their own site coordinators, volunteers, mentors, and links with community agencies. The afterschool director, who may have a community education or community agency background, serves as the hub that connects all staff and partners. This background is usually seen as an enhancement to the program, since the director has existing ties to the community and to community agencies.

There are many positives associated with this type of background. However, principals who plan a different leadership construct should realize that afterschool directors' connection with the school is often nebulous and distant, although one hopes cordial. This leads to a distancing between the regular school day and what is provided during the afterschool program.

Afterschool programs usually connect to schools through cooperative agreements between the district and community agencies that help provide funding and/or programming—and most likely receive grants from the 21st CCLCs program, as it is the primary source of

funding for afterschool programs in the nation. Grants or other monies are funneled through the district, based on winning grant proposals, enabling staff to be paid through the district bureaucracy and the program to function. The district also provides homes for the afterschool program(s) in different schools, and school facilities are used for various activities, such as the gymnasium for sports and classrooms for enrichment and other supervised activities.

First Steps

The school improvement plan must include the afterschool program, and the afterschool director is an integral part of this team. If the principal does otherwise, he or she will affirm the "set-aside syndrome" and doom the program to failure. When the principal selects the team or considers self-nominations, he or she usually considers carefully who should chair the committee in addition to committee membership. This membership may have to be changed, which is easier if the principal has revolving terms for team representatives. Besides the afterschool director, strong teachers from at least two core content areas should participate (reading and mathematics are recommended). A parent, another community member with a history of volunteerism in the schools, and a central office representative could compose the remainder of the team.

The committee's first step is determining the program's goals. The goals should be limited and focused. If they are not, they will become barriers to effectiveness (see Chapter 3 for an extended discussion of potential roadblocks to success.) Ideally, the committee may decide on three goals with the first as paramount: (a) engaging, deep-content instruction in core content areas, (b) youth development activities, and (c) a parental involvement component.

The student AYP subgroup data, or achievement data, will be your guide when designing the part of the afterschool program with an academic focus. The committee begins by examining student AYP subgroup data to see which groups of students at what grade levels are not performing at proficiency levels. As some individuals may not be proficient with this type of analysis, present it in as straightforward a manner as possible, or rely on a data expert from the district.

As one example, if a particular subgroup of students is underperforming in reading, you can explain this to the committee—or have them explain it. These students may need more time than is allowed during the school day. If they are high-needs students, as is probably the case if they have been targeted for the afterschool program, their

home life may not permit sufficient time for homework. And without continued, enriched instruction, they may be at a loss as to how to proceed to build their literacy or mathematics skills.

This is one example that shows how principals have data that support the contention that the afterschool plan should contain a strong focus on building English language skills, literacy, and increased knowledge of mathematics. Another example could be that third-grade students in another subgroup are performing beneath proficiency levels in mathematics. In a similar fashion, a strand of mathematics instruction needs to become a component of the afterschool program. Both literacy and mathematics instruction need to be evaluated to determine where they can be strengthened, where there are weaknesses, and to what extent these are curricular or pedagogical.

When changing the afterschool program's focus, you can keep in mind that it is an additional place where the weak areas of the school's AYP data can be addressed and where you, the principal, in cooperation with the school improvement team, can build in academic components for those student subgroups that are not meeting proficiency levels. This may mean two or three academic strands: reading, math, and English language development, depending on the budget. These strands can rotate or remain constant and be delivered to the targeted subgroups that attend the program.

But when building the academic component of the afterschool program, you need to keep in mind that students need a break from the sequential instruction provided during the regular school day— no matter how high its quality. They are tired, hungry, and in need of some physical activity. A well-planned program takes these needs into account, placing them first in the sequence of the program, before academics. After these physical needs are met, and students have a break, they most likely will be better equipped to focus on a content area delivered in an engaging manner.

All the characteristics of leaders meld into practices that you can use to develop an afterschool program with a focus on academics related to the regular school day. In addition, my work on strong superintendent leadership that leads to effective afterschool programs revealed that effective leaders of any school initiative share these characteristics:

- They communicate clearly with staff about the importance of teaching and learning in specific ways.
- They expect and receive consistent reports about the progress and problems of instructional staff.

- They encourage professional learning communities, rather than work that is conducted in isolation.
- They foster ongoing, sustained, and high-quality professional development that supports school improvement and specific initiatives.
- They realize the importance of community and parental involvement and develop strategies that facilitate this collaboration so that it can contribute to learning.
- They reach out to parents and the community in a two-way communications plan that engages parents, solicits and uses their input for planning, and considers their needs.

Communicating With Staff About Teaching and Learning in the Afterschool Program

Convene regular focus groups of rotating members of instructional staff and afterschool staff. If regular school-day instructional staff rotate in small numbers with all afterschool staff, eventually all instructional staff will become familiar with afterschool staff. This lessens the schism between the regular day and the afterschool program, and helps "buy-in" from regular staff. Afterschool staff also feel more committed to the regular day once they understand its goals. And they can draw upon classroom teachers and other staff for advice on negotiating the system if they are unsure of its parameters and unspoken rules.

These focus groups, in addition to meetings of the school improvement team, can be planned in advance so that the principal can gather key questions or concerns from afterschool staff and the instructional staff who will attend. Keeping the group small encourages an easy exchange of ideas and progress, but it also needs to be large enough to keep the exchange of ideas lively. You can easily carry these suggestions back to the school improvement team for discussion—and make sure the agenda is structured so that the afterschool program does not dominate the concerns of the regular day.

If these meetings are structured as focus groups, rather than staff meetings, they avoid the stultifying "show and tell" aspect of many staff meetings. Simply reporting on activities conducted during the month will not advance the goals of the program. In addition to the academic component of the program, regular instructional staff and afterschool staff should discuss the youth development and parental involvement components of the program, as they should be goals for the entire school day.

Manage by visibility. For years, principals have been enjoined to "manage by walking around" (Deal & Peterson, 2003). This means that you are visible in the hallways, classrooms, and lunchrooms (both student and faculty). This visibility needs to extend to include the afterschool program, which often sees no one from the administration.

This means that you need to plan to visit the afterschool program regularly, and you may participate informally and briefly in instruction. In addition, there is a bonus: an informal opportunity to sit down with a staff person and ask a question or questions in a purposeful but nonevaluative manner.

Most people welcome someone else's interest in what they are doing, as long as they don't feel they are being evaluated. It is up to you to set a warm, nonevaluative tone. As that progresses, your involvement and interest will help establish your authority as a key component of the program, and as an internal stakeholder who has an investment in its success. You can also quickly be seen as a link to external stakeholders who know constituents that afterschool staff may not know well. Together, you and other constituents can build a web of external support or supplement the support that already exists. As principal, your presence also breaks down the chasm between the program and the rest of the school.

Communicate with parents and community members. When principals draw on their existing afterschool staff for strategies for enlarging their repertoire of working with parents and community members, they can glean many good suggestions and strategies. This is an area where afterschool staff who come from a community orientation are skilled, and where they have built contacts (most afterschool programs have a parental involvement component as well as links with community agencies).

It is easy for you to become familiar with those links. Some simple outreach includes meeting community agency leaders for coffee or breakfast, discussing and explaining the inclusion of a strong academic component into the afterschool program, and soliciting their input and feedback. If they disapprove, you have an opportunity to probe their reasons, always keeping in mind that the program needs their support to succeed.

Although most high-needs schools may already use these strategies to reach parents, particularly in urban areas, they can be tailored to suit the needs of a particular school, district, and community. Many schools send materials home in different languages if there are English language learners enrolled in the district. But print materials

often are not sufficient. Radio public service announcements in other languages in addition to English can be helpful, and are used in areas of the nation where burgeoning numbers of students enter school speaking a language other than English.

Enlisting key parents who are respected in a neighborhood or rural area to spread the word about the program can be one of the most effective strategies. Students also can be excellent messengers. You might consider holding a contest with a modest prize for the student who can bring in the largest number of other students to the program. Another suggestion is to award a small prize or hold a pizza party for those students whose attendance remains high and do not have a "drop in, drop out" pattern that can plague the success of the program.

Communicate progress and challenges to the central office. No manager likes to be surprised. Consider the all-too-common feeling of attending a meeting where a key piece of information about your school is revealed to you in front of your staff—and you are caught off-guard. To use the vernacular, a principal feels blindsided.

Keeping the central office informed is vital. You can enlist the help of the district's public relations person, if you work in a large enough district where such an individual is employed (Schneider & Hollenczer, 2005). If you work in a small or rural district, you and your staff will assume that role (and should anyway as discussed above). However, if the district employs a public relations director or coordinator, this individual can become an invaluable support to the program if the goals are clear, the benefits are explicit, and the district sees a payoff.

Receiving Progress Reports

Receiving and soliciting progress reports from the afterschool program staff—both formal and informal—are key to your evaluation efforts (evaluation will be discussed in Chapter 5). It also ties into the accountability and reporting lines you are building for the program— and to future evaluation of program effectiveness.

At first, this can be handled quite simply. As you walk around the building talking with staff, and through visits to the afterschool program, it is easy to query individual staff about snags they are encountering with the academic component of the program. For example, some questions might be these: How is the stronger focus on academics meshing with the rest of the program? Is it a successful fit? If not, what might make it a better match? How are students

responding to instruction? Does it need to be tweaked or changed to better engage them? Is attendance stable, does it show dramatic dips and rises, or is it on a steady decline?

A written monthly memo from the afterschool director helps document program progress and provides support are you work with the central office and school board. No doubt you will have to deliver reports and possibly speeches or informal talks to community members, school board members, and central office staff. Both "walk-around" information gathering and formal reports can build your knowledge base so you will be well informed about both the advances and the challenges the program is facing. And rather than presenting a completely rosy picture, if the program is running into some problematic areas, you need to discuss these early on with key individuals so that shifts and changes can be made. As building leader, your honesty will improve the program and help hone its mission.

In addition to building a knowledge base, establishing positive relationships, a supportive presence, and clear reporting lines will help the afterschool program succeed. In one midsized district I visited, reporting lines were blurred to the point of being almost nonexistent.

The afterschool director "thought" she reported to one principal, although the program was housed in four buildings. The central office told me that she reported to the assistant superintendent who supervised Title I. The other three principals said that they were unsure exactly what her job was, because she never communicated with them. They "guessed" she reported to the other principal, and they were irritated with that arrangement. The lone principal said there was no formal reporting arrangement; he reported to the assistant superintendent for curriculum and instruction, and if she had questions about the afterschool program, he could handle them. Eventually the afterschool director was fired, replaced by someone new close to the end of the grant, and the unsuccessful program was jettisoned.

This scenario can be avoided if reporting lines are clear (e.g., if a program is housed in four buildings with four respective principals, one principal can be the point person with input from the other three principals).

Encouraging Professional Learning Communities

Just as the school improvement plan most likely contains an element about professional learning in small communities within the school, this approach can be encouraged with afterschool staff. Particularly

with the push for a strong academic component, all staff need to know what everyone is doing and be congruent with programmatic goals—rather than laboring in isolation.

For example, if a particular literacy lesson has been chosen, all afterschool staff should at least have read it and be familiar with it. If a student straggles away from the instructor at some point or asks a different staff member a question about the lesson, the staff member can take this as a rich opportunity to work with the child—but this is much less likely if the staffperson has not read the lesson or participated in a discussion about it in an afterschool program staff meeting.

The afterschool director should be responsible, in tandem with the principal, for building a professional learning community for the program. Site coordinators and program volunteers can feel they do not have the expertise to participate fully in the program, and if the afterschool director is too busy to engage with them, they are left to their own devices. Frequently, as some told me, they flounder and eventually leave the program, resulting in a high rate of staff turnover—a common barrier to program effectiveness.

High-Quality Professional Development

Next, work with afterschool staff to construct a way in which they can meet purposefully to further their own understanding of their program goals and delivery. This does not need to carry the label "professional learning community," although you may consider it to be one.

At first, their time and scope may be limited to discussing the new role that academics plays in the program. Staff may focus on student reactions to academic content and delivery. After a suitable interval of time, they might consider where changes can be made (if needed) to make this portion of the program more effective. And how you might help.

Make this component of the program a part of the informal and formal reports you receive and solicit about the program. If you are not informed regularly—and remember, that information must be sought—you will not be able to help steer the program in the right direction.

Working With Parents and Community Members

The opportunities to work with parents and community members are almost endless. The only limits are imagination and time. One suggestion is to work from the existing parent base already active in the

school. This includes the PTA or PTO, parent volunteers in the afterschool program, parents of students who are enrolled in the program, aides in the program, and site coordinators who have children in school. Regular-day instructional staff are also key.

I believe, based on my prior study (Lockwood, 2003a), that when principals work with afterschool directors and staff in a collaborative approach that uses a two-way communications strategy, the result is positive for everyone concerned. The key is to plant the idea that principals, as the school's instructional leaders, need to reach out to the afterschool program to extend the curricula and instruction already present in the school, make the school improvement plan transparent and accessible, and not wait for afterschool staff to come to the building leader.

Engaged Learning

One model of learning that qualifies as engaged learning—and provides solid criteria for learning in any portion of the school day—was provided by researchers Fred M. Newmann and his associates at the University of Wisconsin's Center on the Organization and Restructuring of Schools. They amplified the original concept of engagement by furnishing specific ways to help students engage with content and instruction.

One way to do this, they contended, is through "authentic pedagogy." While authentic pedagogy has a significant role during the regular school day, it can be used in substantive, enjoyable ways in the afterschool hours.

Authentic pedagogy has the following components, which do not have to be complicated when implemented in actual teaching and learning that is age appropriate:

- *Construction of knowledge.* Students engage in higher-order thinking activities, arriving at conclusions or hypotheses that produce new meanings or understandings.
- *Disciplined inquiry.* Students use deep knowledge and engage in substantive conversations. They engage in extended dialogues with teachers or other students about the subject matter in ways that develop shared understandings about ideas, issues, or the discipline.
- *Value beyond the school.* Students make connections between what they are learning in school and public issues or personal experiences. (Newmann & Associates, 1996, p. 17)

Sound Leadership Strategies for Improved Student Proficiency Levels

Connected closely to authentic pedagogy are leadership *strategies,* in addition to the behaviors listed previously, that can elicit improved student proficiency levels. The first is to model learning.

Modeling learning means that the entire school becomes a transparent environment. It is skills based and collaborative. Principals and instructional staff shift to an approach in which they continually evaluate their own skills so that they can prove their worth to the organization. If deficits exist, they are ready to take steps to address those deficiencies.

One specific way school administrators can model learning is to always attend teachers' professional development (Barkley, Bottoms, Feagin, & Clark, 2001). If they choose not to attend because of other duties, they show that professional development really isn't that important—at least not to them. They are expecting something of their teachers but refuse to participate in it.

All levels of school staff need ongoing, high-quality professional development. This does not include "one-shot, drive-by" workshops so despised by teachers for their superficial content and "flavor of the month" feeling. The same principles of instruction that apply to students are equally applicable to adult learners. Material should be engaging, delivered in an interesting manner, and conducted over a sustained period of time (perhaps some intensive back-to-school time in the summer combined with a winter refresher course). Preferably, this is not done *en masse,* but in small groups that can continue on their own during the school year.

Afterschool staff are no exception to this rule. With a changing program, and with one that is still nascent in its focus on academics, highly skilled individuals who offer technical assistance/professional development in the academics component of afterschool programs— *and in its mesh with the other components of afterschool*—should be brought into the school and budgeted out of the afterschool program's grant.

Principals can also facilitate a component of this professional development. Explain the program's goals, bring in representatives from the afterschool committee, show student subgroup AYP data, and discuss both program content and delivery. You will emerge as a key player who is both encouraging and helping to develop the program.

Another strategy is to provide reasons for others to learn (Barkley et al., 2001). In keeping with the tenets of authentic pedagogy, principals and teachers encourage students to be active participants in their own learning. Their assignments are interesting, often inquiry and

project based, resulting in real-world products that they can explain and display. These products are connected to their experiences outside school and help prevent a disconnect between school life and the rest of a student's experience.

Successful administrators rely on a coaching approach, rather than didactic methods to learning. While coaching provides critical feedback, it also provides support for questions and risk taking (Barkley et al., 2001). When administrators coach teachers rather than evaluate them, they are more likely to raise teacher expectations (Barkley et al., 2001). The same applies to afterschool staff, who can join a "critical friends" network (Sizer, 1984).

Not "The Same Thing, Only Louder"

All of these strategies and leadership attributes can be applied to the design or change of afterschool programs to include a stronger emphasis on academics. What some call "the same thing, only louder" is not acceptable in afterschool programs—just as sagging instruction should not be the norm during the regular school day. Afterschool programs should not mimic a school day of poor quality—nor should a strong principal allow a substandard day of instruction.

The key is to provide opportunities for enriched, engaged learning time. High-quality project learning should consist of the following:

- *Authenticity.* The context of the school and community are used to teach academic and technical skills.
- *Academic rigor.* Higher-order thinking skills are nurtured, as are research methods from academic and technical fields.
- *Applied learning.* Students use academic and technical knowledge to acquire the problem-solving, communication, and teamwork skills they will need in the workplace.
- *Active exploration.* Students extend their learning beyond the classroom to include learning based on work (if age appropriate), community-based activities, and technical labs.
- *Adult relationships.* Adult mentors will be involved in student learning; these mentors can be drawn from the school and community.
- *Assessment.* Students' work can be exhibited and assessed according to both the students' personal standards and the performance standards set by the school, community, and state. (Barkley et al., 2001)

Leadership, Academic Achievement, and Afterschool Programs

The precepts of leadership, engaged student work, and dynamic teaching and learning can be connected in the afterschool program— but it will be a challenge.

One starting point is to enlist present partners, most of whom want to work well with the principal. In one school district in the Pacific Northwest (name not given to protect its anonymity), a social service agency director told me,

> The principal's investment and support of the program is very important, because when I have my staff out there, they're really flying solo to a certain extent . . . you need a go-getter, but at the same time, someone who can take instruction from someone I consider their outside supervisor, who is the principal. We're housed there. We're in their home, so we have to respect the simple things that you really need the school's blessing for. (Lockwood, 2003a)

The same person commented on what makes an experience unsuccessful.

> There [can be] a lot of "What's this program? What do you guys do?" A lot of that should be my part, going in and reclarifying for new people. But on occasion you'll get schools that feel they have a different mission or are going in a different direction and this afterschool piece over here is something they're not quite sure what to do with. They've got so many things going on themselves. (Lockwood, 2003a)

The Afterschool Curriculum

While the interaction of the instructional leader with staff, students, and stakeholders is critical to accomplishing the goal of boosting student proficiency levels, research tells us that a strong predictor of improved student achievement is the content that is taught. What and *how* are equal (Newmann & Associates, 1996). Depth versus coverage must be balanced, with weight given to depth of understanding.

This brings principals and afterschool staff to several critical decisions about the curriculum, structure, and pedagogy of the afterschool

program. If necessary, this can be used as a template for supplemental educational services.

The following questions need to be asked in a professional learning community setting:

- How do we propose to heighten student proficiency levels in core content areas such as reading and mathematics?
- Do we have the right blend of staff for achieving that purpose? If not, how can we recruit and hire them?
- How should we structure the program so that students are not unduly taxed and learning is fun, project based, and enriching?
- In what ways can we reach out to parents, family members, and other community members to involve them in our program, either as volunteers or community supporters—or both?
- How can I enlist instructional staff from the regular school day to support the afterschool program and its goals?
- What is the best way to evaluate progress toward improved student proficiency?

Starting the Program: Key Questions

No matter how the school improvement program is constructed, certain key questions remain as you convene staff, parents, and other educational stakeholders on the afterschool committee:

- Does staff understand the new goals of the afterschool program (e.g., an increased, in-depth focus on academics in core content areas, intended to boost student proficiency levels for targeted student subgroups, in tandem with youth development and other enjoyable activities)?
- Are you convinced that a more focused, stronger emphasis on academics in your afterschool program is worthwhile and necessary?
- Do you know what curricular and other resources are available to you and your staff?
- Do you know how you want to evaluate the program?
- Have you established an afterschool team that is aligned with your goals? (Adapted from Nelson, 1986.)

These questions will form the basis both for your evaluation plan and for the strategies with which you will overcome barriers to effective programs (discussed in Chapter 3). Overcoming these obstacles will be critical to your success as you move forward with a strong learning focus in your afterschool program.

3

Overcoming
Common Obstacles

F ar too many new programs fail, drowned in a sea of good intentions. As any principal knows, challenges to any educational improvement abound. The causes are many; the solutions can be simple or complex. In this chapter, I discuss the most common obstacles to success in afterschool programs along with suggested solutions. The chapter includes a checklist that can be completed to assess where the school stands in its planning of the program and constructing an evaluation plan (see Chapter 5 for a discussion of evaluation). This checklist should address the most central challenges and help as the principal moves from committing to the program through evaluating its effectiveness. In Chapter 4, I present mini–case studies of successful principals who have overcome these obstacles.

Remembering the five R's of the newly focused afterschool program, as described in Chapter 1, is an overall way to help organize the scope of the program:

1. Recognize and build upon the climate of accountability that has been created by the provisions of NCLB.

2. Realize that afterschool programs have the potential to provide a venue for boosting student proficiency levels, particularly in low-performing schools with large numbers of low-income, high-needs students.

3. Remember that afterschool programs are going through a painful transition from their original goals to a new goal.

4. Relate the new academic emphasis of your afterschool program in a two-way communications strategy to your school's instructional staff, central office, the school board, parents, community agencies, and all other instructional stakeholders to ensure maximum buy-in to the changing emphasis.

5. Review the ways in which your program has been successful or problematic; use that information to shape your new program emphasis.

More specifically, under the five R's, you have a shining opportunity to

- Ensure that the afterschool program is an integral part of the entire school improvement plan (Recognize)
- Sharpen unclear or myriad goals to goals that are targeted, focused, and attainable (Recognize, Realize)
- Hire staff who are congruent with and well prepared to implement the program's academic goals (Realize, Remember, Relate)
- Ensure that afterschool program staff and regular instructional staff connect around your school improvement goals and specific plans for the afterschool program (Remember, Realize, Relate)
- Enlist regular-day instructional staff to support the revamped afterschool program, its goals, and its staff (Realize, Remember)
- Select appropriate curriculum materials (Realize)
- Devise a plan to ensure regular student attendance (Realize)
- Establish strong program and staff accountability for positive student outcomes (Recognize, Realize, Remember, Relate)
- Create a sound evaluation plan to assess how well students are progressing under the changed program goals (Recognize, Review)
- Build a strong base of support for the program that includes the superintendent, central office staff, regular-day staff, community members, and parents (Relate)
- Plan early for sustainability of the program (Relate, Review)

Most of the discussion in this chapter that focuses on barriers to success points to myriad goals and critical issues in staffing afterschool programs with an academic orientation.

The Problem of Myriad Goals

Are goals focused and attainable? A key starting point when designing a program is to streamline programmatic goals and itemize them in order of importance. The paramount goal is already something you know well: increasing students' proficiency levels through engaging, enriched learning opportunities. Identifying, at most, two or three other goals and focusing them on school improvement is a productive first step. A second step is to ask a targeted series of questions when you work with the school improvement committee.

Principals and other staff may not realize just how many goals permeate afterschool programs. These typically include, but are not limited to, the following: reducing delinquent behaviors, eradicating substance abuse, increasing safety, avoiding the "latchkey kid" syndrome, involving parents and community members, providing homework help, and teaching a second language, among others.

None of these are negative goals. But if the program is changed to include a specific type of academic focus that will engage students, principals can consider how many goals already exist and whether staff can realistically meet them.

These grant abstracts from the 21st CCLCs database (without identifying schools) illustrate this point (21st CCLCs Profile and Performance Information Collection System, n.d.a):

> The project integrates the following initiatives: extended safe and drug-free afterschool and summer programs for grades K–4; drug, alcohol and violence prevention programs; character education; mentoring programs; tutoring and homework assistance; preschool programs; community enrichment learning activities; parenting skills programs; and literacy training for community members.

And another:

> The project focus will include (1) supervised activities, (2) efforts to reduce juvenile referrals, (3) efforts to raise academic achievement of students, (4) activities for adults, and (5) increased community resources to meet the needs of families.

Consider what will happen if large goals are focused. First: raising academic proficiency levels of students. Principals do not make "efforts." To try implies failure.

Involving community and parents certainly is a worthy goal—but it needs to be one with a purpose. Is it to build a base of support for the program? Is it to involve parents and community members in the academics of the program? Perhaps you want to construct a goal that insists that the afterschool program become an integral part of the regular school day. This fits with the overall intent to increase academic rigor and extend opportunities to learn.

Are there sufficient staff to do the work? When a program suffers from an overly ambitious array of goals (often constructed in an effort to get the grant), there often are not enough staff to perform the overly ambitious scope of work. When funded, one reason a program may not live up to its potential is linked to its overworked staff, who are trying to meet a host of program goals in an unfocused way. They burn out, and the program endures a high rate of transience. Because of the myriad goals usually attached to the grant, funds are diffused across schools and across the overly ambitious program area.

Will the defined goals help delineate the desired and undesired staff? Obviously, goals will determine the type of staff hired. Principals also confront the issue of dismissing staff who are incongruent with the program. If their performance has not been documented, obviously they need a suitable interval to demonstrate whether they can handle new or altered tasks. Again, this documentation of performance needs to be set against benchmarks that are established for the program as a part of the school improvement team process. This brings up the issue of finding qualified staff who will become advocates for the new focus of the program.

The Issue of Qualified Staff

How does the principal hire qualified staff—and do they fit into the overall school improvement plan? There are constant challenges hiring the right people for the job—whether they are teachers who will work during the regular school day or staff for extended-day programs such as the afterschool program. Fit with existing staff matters, as does a critical mass that has bought into the change in the program. Last, a solid program benefits from the right mix of instructional and youth development staff.

"Fit" with existing staff is tricky, because if experienced staff balk at a revamped program, no principal wants to pit new staff against existing staff. This concept quickly becomes apparent as the school improvement team meets and discusses schoolwide goals and targeted

goals for the afterschool program. The primary strategy needs to revolve around recruiting and retaining afterschool staff who fit into the established policies of the district. Just like other staff, they must have detailed job descriptions.

Just as it is desirable—if not necessary—to have a critical mass of afterschool staff that coalesce around the school improvement plan, afterschool staff need to stretch beyond its goals to become a part of the entire school's improvement goals. It is likely that some teachers have emerged as creators and supporters of the school improvement plan. Their characteristics are the ones to match with those of new afterschool staff.

Who is the most essential hire and how does he or she match the program's needs? Of all the staff hired for the afterschool program, the central figure is the afterschool director. Because afterschool programming is not typically a part of a district's educational plan, it can be tempting to select a person who is well qualified in terms of community background but who may not match the academic needs of the school or district.

Tradition makes it compelling to resort to a familiar scenario, looking automatically to external community sources for the hire. And this logic makes some sense, for these individuals generally are skilled at community ties and partnerships. They are accustomed to working with community agencies and parents.

But a blend of community and outreach skills as well as academic skills creates an effective program that meets students' needs. If principals select an individual with the expertise and finesse to deal with the bureaucracy of a district, the odds are much higher that the program will succeed. If that person is a strong midlevel manager in the school and is congruent with the new goals of the program, there is a place for others who have backgrounds more focused in community work or with community outreach strategies.

Ideally, the afterschool director needs to have some of both. If he or she has enough solid knowledge of schools, districts, and core content area instruction, combined with the ability to work well with community agencies and parents, he or she matches what you seek for the hands-on leadership of the strengthened program.

Solid afterschool directors create a chain of excellence. They are able to train their site coordinators rather than adopt a "sink or swim" mentality. Afterschool directors are most successful in this endeavor when they are actively engaged in the school improvement plan, have positive relationships with regular instructional staff, and have a strong relationship with the principal.

This can be encouraged by refusing to let site coordinators play you against the afterschool director—which happens when reporting lines are thinly drawn and accountability is nil (discussed later in this chapter).

Afterschool directors who have histories of community activism typically see their efforts as external to those of the school system, and if principals are not leading the afterschool program, they may unwittingly encourage this approach. It is easy to see why afterschool directors might have this focus if their orientation is community activism. They may believe their time is best spent cultivating powerful members of the community and raising awareness of the program.

This can create a void in leadership at the program level. Site coordinators may flounder under the challenges of a new position and appeal to the principal for help when none is forthcoming from the afterschool director. It is understandable how principals, in turn, could be irritated by this interruption in an already crowded day (particularly in a challenging, high-needs school). This is another reason that staff must be carefully chosen to fit with the new mission of the afterschool program.

The Hiring and Monitoring Process

Is there a structured, team approach to hiring? Usually the principal is able to hire or at least participate in the hiring of the building staff; the district rationale is that the staff will be housed in the principal's building and the principal will hold chief accountability for the success of the afterschool program. But often the principal must work in tandem with community agencies who want to see their own staff hired or who want a substantial voice in the hiring process. Sometimes central office personnel are involved. It is safe to say that in many cases hiring becomes a committee process, but the principal lives with the decision.

Have regular-day instructional staff been considered as afterschool hires? While some principals will hire teaching staff for the afterschool hours rather than community-focused staff in the belief that this will boost student proficiency levels, this option needs to be weighed. While teachers offer expertise with instructional materials and pedagogy, there is more than one downside to hiring them for the afterschool program.

Teachers cost more. And teachers are tired at the end of a full teaching day. While observing afterschool programs where teachers were the instructional staff, I saw that the fatigue level of teachers was

noticeable and well voiced. Although teachers were paid more through staffing the afterschool program, they were not shy about complaining that their workday was too long.

Another factor prevailed: the skepticism from central office personnel and principals about teachers' motives. Frequently principals saw these teachers as financially driven, and lost respect for them.

When teachers wanted to work in the afterschool program—and made overtime due to their union contract—principals concurred that they viewed them almost as "soldiers of fortune," seeking to profit from a new program to which they may or may not have held personal commitment. But they saw another problem if only community activists staffed a program.

Another problem that can stem from hiring regular school-day instructional staff stems from the way in which they may approach instruction in the afterschool program. What engages students in the regular classroom may be disastrous in the afterschool program, where life generally is more casual, hands-on, and project based.

There are solutions. Certified teachers who are willing to work a few hours a day can be found in the ranks of recent graduates from teacher education programs, alternatively certified teachers, and retirees who have maintained their certification and often prefer to work part-time. More attention needs to be paid to recruiting from the ranks of retirees in particular, who want to give something back to public education, would like to stay current in their field, and enjoy working with students. Parents can be a rich resource as well and can bring warmth to the program. The following vignette illustrates a program that used parents as volunteers in an engaging project that involved botany and science.

> In one district I observed, students in the primary grades worked on an extended gardening project with parent volunteers. The project began when students and parents grew seedlings in a small hothouse environment within the afterschool area, and neared its completion with students producing salsa pots from all the vegetables that make salsa, complete with a recipe. During the project, they charted the growth of their plants, the amount of fertilizer and hydration as well as the intervals at which they administered them, and evaluated the overall growth of their vegetables against the standards on their seed packets. As the final project, students made the salsa under supervision in the school, and it became a part of a Tex-Mex-themed potluck during the program. They did this under the benevolent supervision of some mothers from the neighborhood, who made the activity fun and related to the real world.

What qualifications are best for the program? Ideal staff are those who believe strongly in the academic goals of the program, have ties to the community, have some background in instruction, and are willing to wade their way through the intricacies of the school district curricular goals and standards. They realize that in order for the program to succeed, they must be able to navigate the system—and they must be able to build a strong relationship with the principal.

Staff who are responsible for the instructional component of the program need to be sensitive to lively, engaged learning. They should be certified staff with teaching credentials and a willingness to engage as partners with regular-day instructional staff. They could be people with a background in Title I, adult education, or alternative education.

Do aides in the afterschool program meet NCLB requirements for "highly qualified" paraprofessionals? The heightened quality of paraprofessionals, in particular, can have a substantial impact on the staffing for your afterschool program. Under NCLB, paraprofessionals must

- Possess a high school diploma or its equivalent
- Have either completed two years of study at an institution of higher education, if providing instructional support
- Have obtained an associate's (or higher) degree; *or* have demonstrated through a formal state or local assessment the knowledge of, and ability to assist in instructing reading, writing, and mathematics (U.S. Department of Education, n.d.b.).

There is some leeway on these credentials. For example, paraprofessionals who work solely as translators or who work only on parent involvement activities do not have to meet any requirement other than the high school diploma. Paraprofessionals must work under the direct supervision of a "highly qualified teacher," which suggests at least some credentialed teachers must be employed in the program. Both Title I and II funds can be used to help paraprofessionals meet the new requirements (U.S. Department of Education, n.d.c).

Hiring: Successful Practices

Is there a well-constructed hiring plan? At one district I studied, staff were hired with superb credentials, far above the norm for typical afterschool programs hampered by low pay. Salaries for these individuals were a priority in the grant budget.

Goals were focused. The program was limited in scope to an alternative approach to working with students who were severely at risk of academic failure and dropping out. The two key staff were a former principal of an alternative school, budgeted at 50 percent, and an MSW social worker, also budgeted at 50 percent. The remainder of their time was spent elsewhere in the district. Each had a particular skill set that made the program and their work with students highly successful, and because they were already absorbed into the culture of the district through the remainder of their time, they "spoke the language" of schools and knew how to negotiate its bureaucracy.

This approach sidesteps the syndrome where afterschool staff feel left out of the school culture, a common complaint. When afterschool programs are not staffed by teachers—and they frequently are not due to cost and exhaustion factors—staff can feel they do not belong in the school environment. They may believe that teachers do not include them in discussions; that teachers do not like to share their classrooms; that teachers object to the mess that might result from afterschool activities; and in general, that teachers do not see the point of afterschool programs—regarding them as extended day care for many children or simply "fun and games."

Consider the following scenario: In a district in the Midwest, the afterschool director worked hard to build a good relationship with the business office personnel. This paid off when she had to negotiate salaries for her staff within the grant proposal and hard-line business staff argued with her about such trivial points as fifty cents per person. Finally, an adjustment was made, and goodwill was maintained. As the head business office person said, "We had our moments, but she [the afterschool director] is a good girl." Far from a condescending or sexist remark, this comment—in content—demonstrated that the afterschool director was willing to learn the language of the district but also to continue to argue her position with diplomacy.

Is there a specific hiring strategy? Many principals develop a committee approach to their hiring. As they do so, they find that a focused set of questions, used for each candidate, helps the committee reach consensus about the ability and fit of each person for the program.

You may be looking for the perfect person. Rest assured no such individual exists—however, this is no reason to completely lower your standards. Key questions you might ask include the following:

- How will this person complement the organization?
- What are this person's capability, skills, and knowledge?

- Is the individual experienced in at least one area of academic content (literacy or mathematics)?
- Is the individual open to the opinions of others?
- Does the prospective hire have some knowledge of how schools and districts operate?
- Is the prospective hire enthusiastic about the academic goals for the program?

When you construct your hiring committee, it helps if you include a teacher or two from the content areas that will be emphasized in your program (probably mathematics and reading), as well as a parent. This enlists their support of the staff at the outset and helps avoid potential problems with fit. Not only that, the teachers and parent can convey word back to the school and community that, together, you have made a good decision. Be sure to include a representative from the central office, such as the Title I coordinator.

Developing Staff Accountability

In what ways are your afterschool program and staff accountable for student success? A common pitfall is a lack of accountability. The following example illustrates the disintegration of an entire afterschool program.

In one focus group I conducted with afterschool staff, site coordinators were present along with the afterschool director. Despite the presence of the afterschool director (or perhaps because of it), the site coordinators unleashed a torrent of frustration, ill will, and dissatisfaction with their own lack of training and inability to select materials. None had been provided with materials when they began work in the program, nor did they receive help on any steady basis. All turned to me at the focus group and said that they did not understand what the afterschool director did. One site coordinator "guessed" that she worked in the community. Another said she never saw her. Still another surmised that she spent most of her time housed in another school.

When staff complained of neglect and their need for help, the director defended herself by saying that she regarded staff as professionals who should not need her help. It was her contention that they should be able to function completely independently and without any supervision. But she had chosen to hire parents with no background or preparation for working in an afterschool program except interest in their child's education.

Site coordinators became furious when she told them they should find their own resources. More than one told her they had no idea where to start. Some were not even used to dealing with the Internet, and did not know how to conduct a search. Others were patching together a program from multiple sources—another big problem at schools where goals are unclear—and knew from the reaction of the students and their own lack of confidence that they were not achieving the goals of the program.

Accountability was threadbare. The principal was accountable, in general, to a central office person in charge of curriculum and instruction for whatever grade group was appropriate (K–3, 3–6). But the principal was disengaged from the program—which had no academic component—and barely had an oversight role. Primary accountability went from afterschool director to principal and from afterschool director to site coordinators.

All of this confusion over reporting lines and accountability stands in stark contrast to truly effective afterschool programs, where clarity of reporting lines is absolute. At these sites, site coordinators go to the afterschool director and receive help if they need it and the resources they need to do their jobs. In turn, the afterschool director has a higher likelihood of the principal's support.

Clarity is absolute, and clarity of reporting lines ties tightly to the program's goals. There is a central message about the program: engaged learning for heightened student proficiency levels. This can mean all sorts of challenging and enjoyable activities that would not be encountered during the normal school day. Perhaps during the school day they would be considered too "messy"—or simply too cumbersome.

Curriculum Materials and Other Resources

What curriculum materials will afterschool staff use, and are they aligned with standards and benchmarks? A common concern of afterschool staff—particularly those who will be working with an increased academic focus—is identifying and using the appropriate curriculum materials for their students. These materials must be engaging, fun, and interesting, and they should leave students "wanting to come back."

While it is possible to work from existing curriculum materials in a district and adapt them to an afterschool program, this can be tricky. Much as it is desirable to ensure a seamless day as long as the afterschool program is engaging and lively, encountering the same

curriculum materials as those used during the regular day may tax any student. A different approach, and different complementary materials, may prove a wise plan.

There are many commercial curriculum products for use in schools with afterschool programs. But these must be aligned with the district curriculum policy, which is aligned with the standards set by the state. The curriculum materials may be useful, but need to be carefully screened because (a) they may have no relationship with the district's academic goals; (b) even if aligned, they may vary widely in quality; and (c) they need to be cautiously vetted by your school improvement team to ensure their appropriateness for the afterschool program—particularly when you consider it an integral part of the school day.

Has the staff discussed the potential challenges to implementing solid curricula in afterschool programs? The National Institute for Out-of-School Time identifies the following obstacles to implementing appropriate curriculum in afterschool programs:

- Child dynamics
- Environment (Are there constraints on space?)
- Content knowledge (Do activities require knowledge from instructors they may not possess?)
- Storage (Is there space to store ongoing projects? If not, other projects must be selected)
- Administration and staff (How committed are staff to programmatic goals?)
- Materials (Does your budget permit buying and storing necessary materials?)
- Time (How is program time structured, and how will this affect the programs you plan to do?) (NIOST, 2005.)

NIOST also provides the following broad recommendations for structuring an afterschool curriculum:

- Provide structure with flexibility, balancing structured activities with unstructured time.
- Plan a variety of activities (academic, social, physical).
- Give students choices (choices allow students to take responsibility for their learning).
- Provide opportunities for student input.
- Know your students, staff, families, and community.

- Pay attention to time, environmental, and staffing constraints.
- Pay attention to the budget (activities must work within the budget). (NIOST, n.d.)

Regular evaluations, observations, and hands-on involvement need to occur to ensure the viability of the program. Fashola (2002) describes a wealth of programs that are replicable in her book, and Gordon, Bridglall, and Meroe (2005) discuss how "supplementary education"—not to be confused with Supplementary Educational Services—is the "hidden curriculum of high academic achievement."

Plans, Goals, and Implementation

Is the plan for the afterschool program concrete? This plan must be something you can oversee, communicate clearly, and implement. Strong evaluation of programs has been spotty and unreliable aside from some exploratory evaluations (in many cases, biased by advocacy). It is much easier to evaluate a program that is clearly articulated from the outset.

Remember how not everything is equally important? Since the changed focus of the program has to do with increasing academic achievement, place your primary emphasis there, and rely on program staff and a third-party evaluator to design and execute an evaluation plan for the remainder of the program.

Do you know how to construct a solid plan for the program? Remember, there is no need to enter the realm of quasi-experimental design or randomized field studies. The principal's evaluation needs to be practical, easy to understand, and relatively simple to implement.

You can start by asking the questions you want the evaluation to address. Do you want to know if student proficiency levels are improving as a result of program attendance? What about the choice of curriculum materials? Are hires appropriate for program needs? How well do afterschool staff integrate with regular instructional staff?

Focus questions into the following categories:

- *Desirability.* Should you have a focus on academics in your afterschool plan? How important is this emphasis? How do you know?
- *Feasibility.* If your school is just beginning to consider incorporating academics into your afterschool program, does your program budget allow this emphasis?

- *Fidelity.* Has the academic component of the program been carried out as it has been intended? How do you know?
- *Effectiveness.* Is the focus on academics something that is good for the entire school? Does it benefit regular instructional staff? Does it further your school improvement plan? Finally, what is its impact on the students enrolled in the program? (Nelson, 1986)

Don't try to bluff your evaluation. If you try to "wing it," the program will suffer. Staff and community members quickly will realize that you are not discovering the desirability, feasibility, fidelity, and effectiveness of your program.

Are student outcomes a critical part of the plan, and do they relate to the program's goals? This is the critical question of effectiveness. Are you assessing student acquisition of knowledge and skills related to the academic goals of the program using imbedded measures that help push student progress?

Is the academic content of your program designed to mesh with the goals of the district and state standards? When answering the desirability question, ask if the academic component of the program aligns with district and state standards for pedagogy and curriculum. Are you going through the motions, or do you believe this program will benefit your students?

Is the program feasible? Can the budget be focused so that appropriate, well-qualified staff can be hired? Can you invest in high-quality curriculum materials that meet your standards and benchmarks? Can you carry off a redesigned program to your school's, community's, and central office's satisfaction?

Does the program demonstrate fidelity to the district's overall plan and to the original conception of the academic component of the program? Once the program is operating, is instruction operating the way you intended? Does it mesh with your school improvement plan? Is the program offering an enriched, engaging learning experience to students? What changes might you need to make to ensure it meets its goals? Do the goals need to be refocused?

How effective is your program? If you can answer the desirability, feasibility, and fidelity questions in the affirmative, then it is time to focus on effectiveness. A program is only effective if it can show benefits to the students and school as a whole.

The following checklist will help guide your overall vision for the program and the schoolwide staff planning that will follow.

Planning for Program Sustainability

Has the school improvement team established a plan to sustain the program after its original grant? I observed successful districts where schools or groups of schools shared resources in imaginative ways, working from a combination of grants, donations, active fund-raising, and money from community agencies. One key to sustainability is proof of effectiveness.

Success builds success. You and your staff can use your evaluation of effectiveness as a tool for establishing data to promote the future of the program. Where the program shows weaknesses, improve it with appropriate curricula, a change in instructional approach, a shift in program structure, and other ideas the school improvement team generates.

Always remember your program rationale and be able to communicate it clearly. You want all of your students to attain higher proficiency levels. Your afterschool program is a key means to this end. A seamless day, high-quality instruction, and engaging academics aligned with district and state standards also give a high-needs student more opportunity to learn—commonly called "time on task."

Reapply for grants where possible, using the evaluation data as an integral part of your proposals. Proposals need to demonstrate clear goals and evidence they have been met. Make sure that your plan for sustainability does not include simply "more of the same," but an insistence on continued progress toward meeting key goals, which will include fine-tuning the program where necessary.

It cannot be overstated that your key to sustainability will be found in sound data you can use to secure further funds—in grants, donations, or a part of the district budget—as well as your commitment to continuous improvement.

In Chapter 4, I focus on specific examples of successful principals who have built effective afterschool programs with a strong academic component.

Table 3.1 Core Planning Questions

Core Evaluation Questions	No Solid Evidence	Some Evidence	Substantial Evidence
1. Have we established that our program is desirable?			
2. Does our program meet student needs to increase academics?			
3. Does our program have an initial base of community support?			
4. Do we have the resources—money, time, and staff commitment—to carry out this program?			
5. Can we show that the improved program is feasible?			
6. In what ways does our program demonstrate fidelity to the original plan?			
7. Are our goals clear and focused?			
8. Is the afterschool program a key component of our school improvement plan?			
9. Do regular instructional staff and afterschool staff interact and share progress?			
10. Do we have a strong hiring plan in place?			
11. Have we secured appropriate curricular materials for our program?			
12. Are afterschool staff well versed in enriched, engaging instruction?			
13. Do we have a plan to ensure regular student attendance?			
14. Have I established strong accountability and reporting lines for the program?			
15. Do student proficiency levels show that students benefit from participation in this program?			
16. How do we know and ensure that our program is effective?			

4

Profiles of Successful Principals and Programs

In this chapter, I profile three principals who lead afterschool programs that focus on raising student proficiency levels in engaging and enriching ways. Their names and exact districts are not provided; they were promised anonymity in exchange for candor in their comments. These principals show different ways in which afterschool programs can extend the regular school day to boost student proficiency levels and provide other benefits to students as well.

"If You Understand the Land, You Understand the Students"

In Painted Valley, a small rural district in the Midwest, Tom Johnson, the middle school principal, has a relentless attitude toward student success—and he believes it begins with a thorough understanding of where and how they live.

Although diffident at first, he rapidly warms to his topic, telling me that he grew up hardscrabble in the district and knows every square inch of the area. Interviewing him, I get the feeling that I could walk with him across remote land left to seed and Johnson would know exactly where he is, how far he stands from the nearest student's home, and how well that student is doing in school.

Johnson wants his visitor to understand the land on which his students live—the sprawl, the isolation, the long transport to and from school for students who live outside the small town, and the pockets of severe poverty. To get a real feeling for the district, he shows a large, well-worn map of his district that is tacked to his office wall.

He jabs at the map to show the distance from the town to the farthest-flung home where a student lives.

And he talks about the river that runs through the district. This river, Johnson says, is his nemesis, his continuous challenge to ensuring that students in his district receive the educational services they need.

Townspeople who commute to the nearest city, Johnson explains, typically take a car ferry to leave the town to go to work. But, he points out, a school bus does not belong on a ferry, which would dramatically shorten the distance between schools. Instead, the buses must travel a long and convoluted route, through all kinds of weather—the Midwestern climate is harsh.

Johnson is visibly affected by the fact that kindergartners must ride the buses, sometimes for over an hour in each direction.

"They are so small," he laments, "and they get so tired. And then they face that ride."

This transportation problem was a key challenge, but Johnson was able to surmount it in this planning.

Changing Demographics, New District Challenges

But first, Johnson points to wide disparities in his student population—and across the district K–12. The town's total population numbers 1,880; approximately 80 percent of his student body of 920 qualify for free or reduced lunch. While most are white, the district has seen a steady growth of Hispanic families—98 percent of whom speak Spanish as the primary language and fall below the poverty level.

However, his district recently has seen an influx of wealthy families from the nearby city into the rural area. Large, expensive homes stand in stark contrast to homes badly in need of paint, often with sagging steps leading to the front door, and a burned-out vehicle in the front yard. Johnson's resolve to provide a superior education for all students enrolled in his school has been spurred, he says, by the glaring disparities between these families and the rural, mostly poor families.

Affluent parents supplement their children's educational needs through private lessons and tutorials, through computer camp, dance

and music lessons, and homework help at home. Most parents are dual-career professional couples skilled in advocacy for their children. Physicians, attorneys, and college professors from the nearby city dominate these families. When not demanding that their children be enrolled in the district's gifted and talented program, they know how to consult with teachers, principals, and the superintendent. Not infrequently, they are personal friends of school board members and influential civic leaders.

This new affluence and influence, Johnson reports, has instilled a new tension in the district that he and his staff must confront. Disadvantaged students cannot dress the way their affluent peers dress. At the high school level, they do not own cars, they cannot afford to go to the prom, and many have responsibilities at home—such as taking care of younger siblings—that their wealthier peers do not have. They do not go on ski trips or visit Caribbean islands during spring break; most have never been outside the state or even fifty miles from home.

To overcome this disparity for his most disadvantaged youth, Johnson believes a strong education is the key. This education, he believes, must include a hefty, well-taught focus on academics, but also something at school that will endure throughout students' entire lives: a supportive relationship with a staff member, a fostering of a talent or interest, encouragement, and most definitely some kindness. He points to his own background to illustrate his commitment to public education in general and afterschool programs in particular—because they extend the opportunities to learn beyond the regular school day. Learning, Johnson insists, must reach beyond the confines of poverty and isolation.

Growing Up Disadvantaged

"I grew up with my grandparents," Johnson says, "and no one much looked after me. They simply were too old. We didn't have much, only Social Security. You learn pretty fast that it doesn't go very far."

Johnson spent most of his out-of-school hours—and truant hours—roaming the woods around his grandparents' small farmhouse. The house holds bleak memories for Johnson, who describes it as "a house that was sort of nowhere."

And he got into trouble. He remembers a teacher who used to say, "There's no delinquent like a rural delinquent," and applies that saying unsparingly to himself.

"I got into trouble with the law," he says, "and fortunately this teacher intervened and helped set me straight. He worked with me in

English class and after school because he knew I liked to write. He paid attention to me. No one much had done this before. I found out I had some ability to write, and I ended up determined to go to college."

Having a special focus and dedicated attention from one teacher was the early foundation for Johnson's commitment to any extra learning opportunity a student can receive—particularly students most at risk of academic failure with a high chance of dropping out.

Rural districts pose extra challenges to afterschool programs because these districts usually sprawl over an outsized amount of sparsely populated land. Transportation home from the program can be a major expense (and obstacle) for the district. The river, Johnson continues to point out, has perplexed and frustrated him, but he found the best solution he could—but he considers it far from ideal. Sufficient money has been allocated in the program budget to allow buses an extra run when the program ends. While this may mean that children are tired when they get home, they do not have to do homework, and they arrive simultaneously with some family member.

Johnson has been keenly aware that working parents who are impoverished may not have schedules that permit them to pick up their children after the program. They also may not be able to participate actively in the program, although they may be committed to its goals. Of course, this means that to have a program, the responsibility for safe transport falls to the district.

Johnson welcomed the opportunity to focus on the middle grades. He believes that middle school students can benefit most from a recharged, refocused afterschool program because they may be the most at risk of failure and eventually dropping out altogether. "Perilous years," Johnson muses, "and years where everything can fall apart."

And he emphasizes, "Sometimes they've dropped out before they've left. Our job is to turn the valve that has disconnected them and reconnect them to learning."

When planning the afterschool program, Johnson knew that the needs of his district had to dominate what happened not only during the regular school day but also throughout the afterschool hours. And he recognized that the two parts of the day could not be detached.

To him, the comparison between connecting the program to the regular day and what occurs during the regular day is easy. "Imagine a fourth grader whose teacher has no idea what went on in the third grade. It's easy to have the same gap between the regular day and the afterschool hours. We planned carefully to avoid it."

Johnson worked with his small cabinet, key community members, principals, and other site-based staff to integrate the afterschool

program into the regular school day. He did this by insisting that it become a key part of the overall school improvement plan.

This did not happen without a struggle, he admits. At first, regular school-day instructional staff were reluctant to incorporate afterschool staff into their planning time, but became less so because of the respectable credentials of these afterschool staff. The afterschool staff, already employed by the district in capacities that extended beyond the afterschool program, had a sense of belonging to the school, district, and overall improvement plan, and skillfully integrated themselves into the school's mission and goals.

"We asked: What are our most critical areas of need? What do we need to do to address those needs? Are we capable of doing it? How much money do we need? Within the budget we've got, how do we allocate resources in the most efficient manner?"

Johnson convinced his team that a significant share of resources had to be devoted to securing high-quality personnel to steer the afterschool program.

"I'd rather have fewer excellent staff than several mediocre ones," he observes.

He hired accordingly—a half-time social worker with an MSW degree and a half-time former principal of an alternative school. Both also worked half-time elsewhere in the district so they had a sense of security.

The program emphasizes bonding to school and a connection to one core content area of the student's choice. If a student shows an interest in math, one staff member with more knowledge of math works with the student to develop and coach the student on a math project. The same is true for literacy. The two highly qualified individuals who staff the program team intensively with each other to ensure that they know and understand the needs of each student.

Both staff members underscore that they begin with students where they are when they enter the program. They do not blame them for past performance. They do not cast aspersions on their family backgrounds or possible lack of family support. If parents cannot or will not participate in the program, staff do not hammer students with this, creating a negative atmosphere. Both grew up in the area—a plus—and understand its rurality and demographics.

Working with the student population served by the afterschool program, they say, requires both a special understanding of the needs of students and a determination to help them succeed. Jean Smith, the social worker, told me that most students in the program enter it with a hostile attitude toward school, developed through poor experiences

in the past coupled with a lack of family involvement in schooling. Most come from impoverished backgrounds, where tools such as computers that are taken for granted by more affluent students are nonexistent. Many have no conception of how to conduct an Internet search. Left behind both academically and socially by many of their peers, they are on the verge of dropping out of school entirely—which seems like a logical response to a punishing experience.

All of these factors, one might think, would predispose students against attendance in the program—but the opposite is the reality. Both the social worker and former principal share empathy for the students' special needs but practice "tough love" when it is needed. This philosophy seems to bond students to the program.

I observed that when a student appeared sullen and disengaged, one of the staff members almost immediately questioned the youngster closely. "Why aren't you doing this Internet search? What don't you like about this project? Do you think that is a realistic attitude? Why? How can we work around it? I'd like you to come up with a solution and then we can discuss it."

Not only did this questioning elicit answers about the student's projects, but it pushed students to articulate attitudes toward learning, participation, and the program itself. At times, students were open about momentary dislike of a staff member. The same questioning followed. Staff were skilled in knowing when to ease off and be gentle with a particularly fragile student, and when to toughen up with a particularly stubborn student.

This communication—perhaps alien to many if not most students in the program—seems to keep them coming back. Having both a female and a male staffing the program also has been effective. Sometimes the girls gravitate to the man and other times to the woman, depending on the issue or problem. The same is true for the boys enrolled in the program.

Unfortunately, parent involvement is virtually nonexistent, and staff do not place that expectation on students. Realistic in many ways, they fill an extended role with students, realizing that while they cannot substitute for a parent, they can fill a void.

Although Johnson won a 21st CCLC grant for this afterschool program, the superintendent also feels strongly about it, and has included it as a line item in the budget so that the program is assured it will continue after the grant ends. This is an enviable situation for most afterschool programs, fraught with concerns about sustainability.

Solving the transportation problem was knotty, but Johnson succeeded. He worked with the superintendent so that sufficient grant

funds were allocated to transport students participating in the program to and from school. The program does not have a staggered schedule as allowed in some large districts; this holds down the cost of transportation, but it remains a chunk of the budget.

Painted Valley is a sterling example of a district with a program that operates under the guidance of a devoted principal, with the full support of the superintendent, central office, and school board. It is faithful to its 21st CCLC grant, which charges it with providing enrichment and academic learning opportunities for youth at special risk or from impoverished backgrounds. Instead of fobbing off staff with poor salaries, and running the common risk of staff transience, a considerable investment has been made in both salaries and staff percentages, so that staff expertise with the student population is guaranteed. Engaged learning time is not something with which staff must grapple.

This program follows sound precepts:

- The principal is a strong and invested leader in the program's success.
- The staff are highly qualified and understand the students with whom they work.
- The staff are also employed elsewhere in the district, which ensures knowledge of the district's organization and the school's goals.
- The staff are included in the overall school improvement plan and their goals mesh with those of the regular school day.
- Engaged, enriched learning time along with bonded relationships with adults and school are the focus of the program.
- The program is assured of sustainability through the superintendent's and school board's commitment.
- A consistent funding stream ensures the program's sustainability.

Pacific City: Collaborating for Success

Pacific City is a moderately sized city in the Pacific Northwest, with a range of demographics. The city's population numbers approximately 230,500. It is the third-largest district in the state, with a total student population of approximately 36,000. Its minority students number 34 percent, with the largest number from the town's growing Hispanic population. Approximately 89 primary languages are spoken in the city's homes. Fifty percent qualify for free or reduced lunch.

The city faces many challenges: English language acquisition, disparities in family income and educational level, and many disadvantaged students—although the district is considered one of the finest in the state. Pacific City prides itself on its relatively uniform academic performance, but the principal of Northwest Elementary School tells the interviewer that it is hard-won with the students who attend her school—and others in the district. The school is old and so overcrowded that students spill over into portable classrooms. I notice wavy linoleum in the hallways, bathrooms that are far from clean, and walls badly in need of paint. Old furniture is stuffed into a front hallway for no apparent reason. As a result, a certain dispirited quality pervades the school despite bright student artwork that is hung throughout the hallways. Staff, she says, make the best of this situation, but it is far from ideal, and reinforces the disadvantaged status of most of the school's students.

Leadership for Enriched Afterschool Academics

Laura Vogel, Pacific City's principal, has been the school's administrator for five years. During the past two years, she has worked to shift the focus of the existing afterschool program toward a stronger focus on academics—primarily literacy. In my conversation with her, Vogel, a lively woman with dramatic mannerisms, speaks first of the barriers that principals have to overcome.

"Of course one size does not fit all," she begins, "but there are some general precepts that do apply. I would tell other principals to expect recalcitrance on the part of afterschool staff and regular school-day staff *until* they fully understand the goals of the transformed afterschool program—and how both parts of the school day mesh with each other."

Vogel, who conveys a sense of spirit about the ways in which her school will improve the academic performance of all students, does not see ESEA/NCLB as particularly onerous in its regulations. Instead, she says flatly that it is the law, and that it has served in her district to spur actions to heighten student performance.

"Because it is the law, we must comply—and we do. And also what we try to do is extend the spirit of the law. Yes, some of the provisions are a challenge for us, but others guide our thinking and our action."

Action, to Vogel, is key—combined with reason and careful planning. At the outset, she brought her afterschool staff into the committee that works on the school improvement plan.

"I counseled the afterschool program coordinator out of her position," Vogel says candidly, "because she simply wasn't a good fit. She had many other strengths, but the changed focus of the program was not going to accommodate her skills."

Vogel worked to help the coordinator find another position elsewhere in the district, pulling on her knowledge of other elementary schools' needs.

"It's a win-win situation," she says, "although it did take a lot of my time to accomplish this. On the other hand, what would we have done with a key staff member who was not qualified for the task?"

Certainly, she emphasizes, any principal must be sure that afterschool program employees understand district policies in general and particularly as they relate to issues of staff performance. Ensuring that staff are fully aware of human resources policies within the district, she says, helps staff know that the principal will treat them exactly like other staff.

The ideal program coordinator or director can be developed as well as hired anew, Vogel says. At her school, she wanted an individual with a background in academic content, the willingness to consider this a critical component of the afterschool program, and a high degree of flexibility.

"In addition," Vogel points out, "I found someone who was likable. Sometimes we underestimate that quality, because popularity is not a job requirement, nor should it be. But the simple ability to get along well with lots of diverse people, including our staff and students, has helped make this coordinator successful—and also aided her fit with the regular school day and its goals."

Staffing, Vogel underscores, is key. "If you have no ability to hire on your own for your program, you are impeded. If you have input, you are aided. But if it is your decision—with a small committee—you are empowered."

Collaboration Among Principals

Vogel and three other determined principals joined forces to compete for a 21st CCLC grant for their elementary schools. Each school was similar in its needs. As Vogel explains, "We thought the sum of all of us would be greater than one of us."

Rather than having one principal taking the lead for the entire proposal, the four principals chose a collaborative approach and divided the proposal between them, each writing a section and then sharing what they had written.

"We tweaked it between us, rewrote, and polished it according to the feedback we received from each other," Vogel says, "and the proposal was far stronger with this approach. We also had our superintendent read it and give us feedback, and the chair of the school board. This involved our district leader and secured her support, and also that of the school board, which has been invested heavily in our afterschool program from the beginning."

To guard against a "silo" problem, the afterschool director is not housed in a single school. She has modest office space in each school and dedicated time in each school to ensure that site coordinators can reach her during those times. Her schedule is also posted to all staff— including regular instructional staff—so that she is accessible by phone during the times she is not housed within a particular school.

"We tried it first the other way," Vogel says, "and housed her in one school. It simply didn't work. The other three principals needed more contact with her, and the staff perception was that she 'belonged' to one school only. That had to change."

With the change, widespread acceptance of the program blossomed. Regular school-day staff began to drop by the afterschool director's office when they were free to chat for a few minutes. The afterschool director made it part of her routine to eat lunch in the teachers' lunchroom. These are small ways, Vogel pointed out, that she was absorbed into the culture and routine of the school.

Focusing on Literacy

Dealing with academic content in afterschool programs is still a new concept and how it should be approached remains controversial. Many advocates of traditional afterschool programs prefer a break between the afterschool hours and the regular school day, arguing that students are tired and do not want more of the same instruction they have participated in during the regular day.

However, recent advocates of academics in afterschool programs believe the time devoted to instruction and learning is most effective if used in a seamless way that uses the same curricula and pedagogical methods employed by regular school-day staff. This presupposes that the school improvement plan guides all school endeavors, both curricular and cocurricular. It assumes that principals assume responsibilities for high-quality leadership and expect their teachers to work with students in ways that engage them in learning—and that carry over into the rest of their lives. Examples of this abound. A student might write an excellent essay that can be entered in a local essay contest. The

local newspaper might be approached for a regular student column that can vary by grade level.

In order for this approach to succeed, four very critical things need to occur:

1. Afterschool staff need to shed the belief that engaged, enriched learning and other experiences occur *only* in the afterschool hours.

2. Afterschool hours should not be divorced from the regular school day but should be an integral part of an extended day that continues an academic focus.

3. The school improvement plan needs to include as active members both regular school-day staff and the afterschool director and any other afterschool key staff.

4. Curriculum materials and pedagogy must be aligned, and adequate professional development must be provided to both regular school-day instructional staff and afterschool staff—with the principal participating.

At Pacific City, all of these factors are in place—which does not mean they occurred overnight. Vogel began with her school improvement plan and alignment of curriculum. She believed that if afterschool staff and regular school-day instructional staff were involved with each other in planning the entire school day—with the understanding that the afterschool hours continued the regular day but extended it in ways that included academics but also offered time for recreation and a chance to "let off steam"—the entire day would benefit.

Staff worked closely with each other, the principal, and the community members who participated on the school improvement team. They agreed that given the needs of the students enrolled in the afterschool program, literacy should be the primary focus. Staff grappled with the best way to approach this.

Already a strong school focus—two hours of literacy instruction per day devoted to increasing writing and reading skills in English—regular school staff argued for an hour of the two hours allotted to the afterschool program. Afterschool staff resisted, contending this was too much time. Vogel was concerned that anything less would be too little, that some students simply require more time to learn. And she was convinced that if approached properly, this amount of time would not be a problem.

Ultimately, staff compromised on 45 minutes, although after-school staff remained nervous about this amount of time. The school improvement team agreed that students first would have time for a snack and some physical activity for the first half hour. That would be followed by 45 minutes of instruction, to be increased to one hour if the 45 minutes succeeded. The remaining 55 minutes would be devoted to physical activity such as recreation (volleyball, basketball, dance, painting, or music).

When planning the afterschool literacy activities, regular school-day staff and afterschool staff agreed that breaking the 45 minutes into a potpourri of literacy activities would not be successful, nor would it mesh with the regular day. Instead, they alternated between reading and writing. One day, students might be given a carefully chosen writing assignment to reflect their life outside school. Usually an alternate assignment was given, so that students had a choice, for those who did not want to write about their lives.

Most chose to. And even when they did not, positive effects were clear. Writing skills were honed. Students had an outlet where they could discuss their families, their preferences—even what foods they liked to eat and special occasions at home.

Staff could work with this information to build their knowledge of families in efforts to draw upon those parents who were available to assist or attend the afterschool program. There were not many, but notices were sent home with students in different languages, public service TV announcements were arranged, and staff called parents on a regular basis—but were careful not to pester them. A common assumption, and one that these afterschool staff observed, is that a surprise visit by school staff is invariably welcome in all homes.

Evaluation

Everyone on the school improvement team—as well as school staff that included afterschool staff—wanted to know if students were learning and if they were enjoying the afterschool program. At the outset, the evaluation plan was devised by the school improvement team to dovetail with that of the regular school day.

There was no problem gaining consensus that the program was feasible and desirable. There was some initial debate about the "hows" of implementation, although those were worked out over the first few months of the program as afterschool staff conveyed their concerns to the school improvement team, talked informally to regular school-day

instructional staff, and drew upon Vogel's regular "drop-in" time on the program.

Vogel served an important nonevaluative role that helped keep the program on course. She made almost daily appearances during the academic component of the program, usually sitting at a table with the children and engaging with them in their work. A smiling presence, she was nonthreatening with students and staff.

Staff found it easy to approach her if they encountered a particular instructional or organizational snag, and frequently these could be solved in minimal time.

But a more formal evaluation process also helped steer the program. A teacher and afterschool staff team—joined by Vogel—examined schoolwide data on state achievement tests, breaking out students from the afterschool program. They looked at student subgroups in the program to see if their proficiency levels were rising or if they had dipped. They also compared their proficiency levels, where possible, to the preceding year when they were not enrolled in the program. While far from a perfect measure, this helped provide some sense of student progress.

Classroom teachers also gave afterschool staff both written and verbal reports of their impressions of classroom participation and understanding of material. And finally, variables such as program attendance, relationships with afterschool staff vis-à-vis school day staff, and disciplinary referrals to Vogel's office were all considered as part of the evaluation of the program.

There were parts of the program that did not succeed as well as other parts at first. Staff struggled to engage students for the full 45 minutes of instruction and pulled upon Vogel and school-day staff for ideas. In the process, they learned a great deal about curriculum and instruction—and developed carefully constructed lesson plans so they were not left with "dead time" to fill that left students restless and bored.

Pacific City is another strong example of a district with a solid afterschool program. It has built the program on solid principles:

- The principal shows her investment through "drop-in," nonevaluative time with the program.
- The principal interacts informally with afterschool staff on their turf, frequently helping solve instructional and organizational problems before they escalate.
- Evaluation is tied closely with evaluation of the regular school day, helping ensure that the day is considered an *extended day*.

- Teachers, afterschool staff, and the principal analyze data to evaluate the program and make changes as needed to ensure student success.

A Program Built on Structure

An elementary school located in a district on the eastern shore of Maryland, Chesapeake Shore, has an unusual approach to academics in its afterschool program—and the principal has been involved in the program's shaping from the outset. Larry Cooper, the principal, saw a profound lack of discipline among the highest-needs students in his student body, and believed it impeded students' ability to learn.

"Many of our highest-needs students," he observes, "come from chaotic family situations. Unfortunately, they brought this into the school. Now, mind you, I am not saying that our more affluent students are exemplary in the classroom management department. This is an issue schoolwide, and one that we are working on."

Why? Because, Cooper says, he and his staff believe that an out-of-control student body that has a random approach to learning is not going to succeed. And nowhere is this more pronounced, he emphasizes, than with the population identified for afterschool programs.

The district is housed in a city of modest size—approximately 250,000 with small urban components. The main manufacturing industry that was a primary source of employment moved to Mexico; other bases of employment include a local branch of a state university and health care institutions.

The city has pockets of affluence where families have renovated old homes in an effort to gentrify neighborhoods. However, those neighborhoods are enclaves in largely impoverished areas where 88 percent of students qualify for free or reduced lunch. English language learners are not a significant portion of the student population, comprising only 12 percent of the district's demographics K–12.

"We decided that in order to extend intensive, engaged learning for them beyond the regular school day," Cooper states, "we needed to start an afterschool program with a very definite structure."

The structure, he reports, alarmed some staff at first. "One person told me it was far too regimented—but the kids actually like it, and we are seeing results." These results have spilled over into the regular classroom, and students not in the program are beginning to imitate their peers.

The Program's Structure

Students are invited to participate in the afterschool program based on their needs and proficiency. Discouraged by previous "drop-in, drop-out" afterschool programs, the superintendent and his cabinet decided that something different needed to occur.

Dr. Janacek, the superintendent, tells the visitor that although afterschool staff reported that the program was chock-full of enriched learning offered through recreation and youth development experiences, but it did not address the academic component students needed, and rather than helping with student unruliness, it seemed to encourage it.

"We knew something different had to happen," he says, "and we decided we could experiment. At the very worst, we could drop the program, although of course no one likes a failure. Or we could modify it."

He found the right principal in Cooper, who already had an afterschool program but was disappointed with its results. A third-party evaluation supported the data analysis of teacher teams and afterschool staff, led by the principal, as a part of the overall school improvement plan. As a result, afterschool staff were absorbed elsewhere in the district, and Cooper developed position descriptions for the afterschool staff that he, his school improvement team, and the superintendent agreed upon.

Students receive a modest financial incentive for attending the program. The stipend comes out of grant funding cobbled together from a variety of sources (not 21st CCLC funds). This funding is administered by a community/school foundation. As the superintendent says, the district regards the program as a pilot, but, since its success, it now is committed to continuing it—although the financial incentive continues to be controversial. Staff, however, believe it entices students at the outset and ensures attendance for the length of time that keeps students in the program.

Two skilled staff members oversee the program—one with a strong literacy background, the other with a robust mathematics background. Both have backgrounds as classroom teachers in the upper grades, and are accustomed to dealing with challenging students. In fact, they are among the unusual group of teachers who are not exasperated or angered if students confront them.

Larry Rice, one staff member, says, "We probably could drop the incentive after the first two months and maintain attendance, but we feel we've made a compact with students, and we'll carry it out

through the school year. It isn't much money at all. And we've noticed they don't spend it on themselves. They take it home and give it to their parents or guardians. I admit, this surprised me. Kids want things. But our kids are developing a sense of social responsibility, and we do tell them that charity begins at home."

Rice and his colleague, Jerry Benson, have approached the curriculum as a labor of love. Although it is aligned with that taught during the regular school day, it is approached differently. There is a stringent insistence on courtesy, beyond what is the norm in the regular classroom ("a continuing battle," Benson tells the visitor, "that we would like the school-day staff to address").

Staff insist not only that students resist the impulse to be unruly but that they learn and practice courtesy. Every moment is considered "teachable," ranging from the time that students spend getting their snack before the program actually begins, to the time that students line up and file out the door.

Students wait for their names to be called before they go to the front of the room to get their snacks, returning to their tables where their seating has been assigned. The tables are round to encourage group discussion—but this discussion is allowed only when staff assign it.

Students are expected to say "please," "thank you," and "excuse me," as the occasion warrants. If they do not, they are gently prompted in ways that do not embarrass them. Staff tell the visitor that if students do not learn social etiquette at home or if it is not reinforced at home, it is their responsibility to teach them how to behave in the world. As a result, there are third graders with exquisite manners who welcome the visitor, show her to a seat, bring her a snack, and ask with interest about her home city. They do so without prompting from staff.

Staff do not blame or indict parents. They never say, as is commonly heard in schools, "send me a child that is ready to learn and I will teach that child." Cooper observes, "Every parent sends her best child to school. And we work with that child."

The Program in Action

The visitor is both intrigued and surprised by the procedure students follow. Afterschool staff use a precise line of Socratic questioning with students, who must stand and announce their name, grade, and teacher before answering a question. This is intended to build their self-esteem ("I am Jane Smith"), their identity with their school, and their affiliation with their teacher. The next time they participate, this

requirement is dropped. Far from being bashful, most students are eager to respond. Questions posed by staff are devoted to problem solving in math or to discussion of a writing or reading assignment in literacy.

Everything is structured, including assignments, but academic work is not scripted. For example, rather than listening to staff read them a story, students are assigned a story to read for an allotted period of time. They know in advance that this story will soon become grist for questioning that will not allow brief "yes and no" answers.

Each student is expected to reason, to back an answer with an explanation or argument, and to be courteous at all times. Staff seek student answers and explanations of the material they have read that illustrate a deep understanding of the material and that build off each other.

For example, if the students have been assigned a story, a question may be posed about a character's motivation. A student responds. The response may be poorly argued, or a guess. Another student takes over with another answer. It may be more fully explicated. Staff never criticize the first student's answer but instead affirm it briefly and move on to the next student.

"Interesting, Jason," might be one staff response to a student, before moving on to another. "What do you think, Susie? Do you agree?"

Just as students address staff by their names, staff address students by theirs, careful to recognize them and build a relationship. This extends after the discussion time to "walk-around time," when staff move around the room and talk quietly with individual students, ensuring that each student receives approximately the same time.

Peer Tutoring

Staff studied other programs while developing this program and have borrowed what they consider the best elements to inform their own efforts. One of these is a judicious use of peer tutoring.

"We saw," Rice tells me, "that peer tutoring could be powerful with disadvantaged youth. While it is typical to pair older youth with younger youth, we do not necessarily differentiate. Sometimes we pair same-grade youth, sometimes not."

As part of their quiet discussion/thought time, students might work together, either reasoning out a math problem or talking through a reading or writing assignment. The visitor observes concentration, but also laughter and friendly banter during these times. Staff keep close watch to ensure that students remain on task, but ward off a

"lockdown" situation where students have no freedom, no pleasure, and no opportunity to have fun.

These dyads have resulted in friendships, Cooper remarks, between students who often are isolated. Frequently pairs of students leave school together, or extend the dyad to another student or two. The visitor observes affection as well between the students and staff as they leave for the day: a hug from a student is not unusual, or a "high five."

Professional Development

This approach is not without its own special challenges. Staff did not learn to conduct Socratic dialogues overnight. Instead, the two staff hired for the program both come from social studies backgrounds where discussions of controversial issues were encouraged. They also worked in laboratory and alternative schools, where experimental programming was the norm. Where laboratory schools provided a "hothouse" environment, alternative schools taught them the need for structure.

Rice says, "Kids need boundaries. They need structure. They feel safer when they have it. Don't we all? Who feels good just running loose?"

Now retired, these staff want to stay involved in education without the full-day pressure of teaching. This, both say, offers the perfect opportunity to continue to hone their skills—because both consider that they continue to learn as they do this—and work with high-needs students.

This does not mean, they both say, that they don't need ongoing professional development or that others choosing this type of program should not have sustained, high-quality professional development.

"In particular," one staff member observes, "inexperienced staff need considerable amounts of professional development. One cost-effective way to do this is to have afterschool staff participate in the professional development that 'day' teachers receive. However, if teachers are not actively engaged in Socratic dialogue, provisions do need to be made for afterschool staff who work in this particular type of program."

What this requires, he continues, is an allocation from the funding that supports the program to ensure that sufficient, appropriate professional development can occur. Afterschool staff also need to know that participation in this development is an expectation and their performance will be evaluated, in part, on their participation.

Chesapeake Shore is yet another strong example of a district's willingness to take risks with its afterschool program. The most experimental of the three examples provided in this chapter, Chesapeake Shore still follows strong precepts:

- The superintendent involved a key principal in the development of an experimental program, willing to abandon it if it failed or change it until it succeeded.
- Unusual approaches to attendance and participation were tried.
- Highly qualified staff were hired.
- Hefty investments in ongoing, high-quality professional development were ensured.
- Monies were allocated from a variety of sources, ensuring sustainability if the program succeeded.
- Peer tutoring helped build student friendships.
- Staff came from backgrounds that enabled them to use unusual pedagogical and structural approaches.

In Chapter 5, I focus on program evaluation that involves the entire school staff.

5

Evaluating Your Afterschool Program

Evaluation can shape the afterschool program. As one examines outcomes, it becomes much easier to focus on the types of necessary resources and conditions that mold a successful effort—one that will engage students, staff, and parents. As the poet T.S. Eliot wrote, "In the end is the beginning." Evaluation can provide the information a principal needs to improve the afterschool program. After all, it is difficult to know where you are going when you are traveling in the dark.

The contemporary writer Doug Adams is less elegant than T. S. Eliot, but eloquent in his own way, when he says, "Don't panic!" Planning and carrying out the evaluation of the afterschool program need not be as tedious or as imposing as one might think. Basically, principals need to answer four questions:

1. Has the afterschool program incorporated elements that characterize effective programs?

2. Is the afterschool program implementation holding true to the original plan? Is there fidelity between what you said you could do and what you have actually done?

3. What benefits or consequences have resulted from the afterschool program in terms of student outcomes—participation and academic achievement—as well as community sentiment?

4. How do you use the information from answers to these four questions to improve the program?

Let's look at how to answer the first question—are you emulating the elements of best practice? The following table lists some key components to consider when developing and maintaining the afterschool program, as they will influence the evaluation and the continuing success (or lack of success) of the program. They also can inform the ways in which program success will be monitored and strategies will be devised to improve and change the program as more data are accrued.

Once the school improvement team has ascertained the degree to which the afterschool program has incorporated elements of best practice and has reflected on suggested changes to the plan, the afterschool evaluation can pose the next question: Is our afterschool program holding true to the original plan? Call it what you will—compliance monitoring, adherence reviews, implementation checks—the team needs to periodically ascertain the degree to which the actual salient features of the program reflect the planned intent. Implementation checklists need to be designed specifically to match your program design, so there isn't one included here. However, there are some dimensions of fidelity that can help teams organize and create their own monitoring form.

Why should you monitor implementation? There are several reasons. First, the process of developing the checklist itself is beneficial for your team. Identifying the salient characteristics of the program leads to interesting insights about what should and shouldn't be part and parcel of the program. It forces the team to get very clear about their expectations. These discussions help to get everyone on the same page. Second, your team has worked hard to propose and design an afterschool program that uses their best thinking and ideas from best practices to deliver the best quality services to students that the resources can afford. It's important to know if the proposed design was actually operationalized so that its success can be replicated. Third, if the student performance results are less successful than expected, it is important to determine what failed—the plan, the test, or the implementation. In other words, was this a bad idea, poor execution, or inappropriate measurement of student results? Fourth, for purposes of communicating the program to the central office, board, parents, community, and school staff, it is critical that your description of the program be based on reality, rather than hearsay or hyperbole. You have the facts in hand to demonstrate what is and what is not being done. Finally, even in this environment of continuous improvement planning, sometimes the best strategy is to maintain the status quo, to not fix what isn't broken. But your team needs evidence to demonstrate why changes aren't always justified or necessary.

Table 5.1 Developing and Maintaining Your Afterschool Program

Key Elements for Evaluation					
A. Ongoing Planning	*Yes*	*To a Degree*	*No*	*Change Needed*	*Notes on Necessary Change*
1. Is your district and school committed to an afterschool program that has a significant academic component?					
2. Does your school improvement plan include the program for afterschool hours?					
3. Do you have a school improvement team that works to make the school day and afterschool hours seamless?					
4. Does your school improvement team work to connect curricula and instruction from the regular school day to the afterschool hours?					
5. Are both regular-day teachers and afterschool staff represented on the school improvement team?					
6. Do all members of your school improvement team have an equal voice?					
7. Does your budget have adequate provisions for hiring high-quality staff?					
8. Have you included funds for high-quality, sustained professional development for afterschool and regular-day staff?					

(Continued)

Table 5.1 (Continued)

B. Program Management	Yes	To a Degree	No	Change Needed	Notes on Necessary Change
1. Can you hire your afterschool staff?					
2. Do these staff show solid evidence of academic knowledge?					
3. Do you see evidence that afterschool staff can teach academic content in ways that engage students?					
4. Beyond involvement on your school improvement team, do you integrate afterschool staff into the life of the school?					
5. Do afterschool staff work in imaginative, concerted ways to draw parents and families into the program?					
6. Do you exert leadership over the program that makes you accessible to staff?					
7. Do you help afterschool staff problem-solve?					
8. Do you evaluate afterschool staff on a regular basis that mirrors your evaluation of regular-day staff?					
9. Have you allocated a large portion of your monies (whether grant money or other funding) to hiring highly qualified staff who meet the program's needs?					

C. Gaining a Base of Support	Yes	To a Degree	No	Change Needed	Notes on Necessary Change
1. Do you work to secure the support of your superintendent?					
2. Do you have concrete strategies for reaching out regularly to key community members to ensure they support the afterschool program?					
3. Do you communicate program goals and progress with school board members?					
4. Do you convey the goals and progress of your afterschool program with the district's Title I coordinator?					
5. Do you work with the district's curriculum coordinator to ensure that your school's curriculum and pedagogy—both for the regular day and the afterschool hours—are aligned with district standards?					
6. Do you confer with other district principals to seek ideas for your afterschool program?					
7. Do you have a solid working relationship with your district's public relations officer, if one exists?					
8. Are you producing news releases that highlight the afterschool program?					

(Continued)

Table 5.1 (Continued)

D. Sustainability	Yes	To a Degree	No	Change Needed	Notes on Necessary Change
1. Are you developing plans for the sustainability of your program?					
2. Do you solicit input about program sustainability from your school improvement team?					
3. Do staff seek funding opportunities on a continuous basis?					
4. Do staff report their findings to the school improvement team?					
5. Do staff have proposal-writing experience?					
6. Does professional development include training on proposal development?					
7. If you cannot obtain funding to continue your program at its current scope, do you have an alternate plan?					
8. Do you communicate program goals, progress, and future plans to the district's grant writer, if one exists?					
9. Have you considered policies to further your afterschool program that are in compliance with your district (e.g., job descriptions, transportation, hiring/firing)?					

E. Evaluation	Yes	To a Degree	No	Change Needed	Notes on Necessary Change
1. Do you have an evaluation plan in place that has been developed by your school improvement team?					
2. Has this plan been approved by your school improvement team?					
3. Does your evaluation plan include a team of teachers and afterschool staff who analyze state and school proficiency-level data to assess student progress?					
4. Does your evaluation shape the ongoing program?					
5. Does the plan include regular monitoring of your implementation?					
6. Based on the results of your evaluations, are you willing to change the course of the program?					

Table 5.2 Afterschool Program Fidelity Checklist

To what degree are the following salient features of your afterschool program plan successfully in place?	*No, Not Yet*	*Few*	*Some*	*Essentially All*
1. Are staff in place, including separate items for coordinators, instructors, specialists, and support personnel?				
2. Are facilities in place, including items about space for instructional activities, staff, and secure storage of resource materials?				
3. Are instructional resources in place, including student, instructor, and parent materials?				
4. Is the program schedule in place, including hours of operation, weekly schedule, and annual calendar?				
5. Are resources in place to support the necessary costs of the program, including staff, materials, and professional development?				
6. Is the program actively managed and supervised on a regular basis, including principal oversight, program coordination, and regular reporting?				
7. Are the number and nature of students participating in the program occurring as envisioned?				
8. Is academic instruction carried out in the quality, scope, and intensity of the plan?				
9. Are parents and community members involved in the program as planned?				
10. Is the evaluation plan carried out to include record keeping and student performance appraisals?				

Try out your checklist. Observe. Talk to people. Look for evidence. But don't overdo it! Nothing unnerves people more than someone running around with a clipboard, checking items off a list. Doing this monthly is probably more than enough; quarterly will do. Share and discuss the results with staff. This is not a secret. This should be an "open-book exam." Discuss how things are working and why you didn't see certain things occur. Maybe it was a bad day or an inappropriate time. But maybe it was a bad idea that needs to be changed. Monitoring is not about "gotcha." It is about finding out how things work and changing them when they don't.

Now it is time to address the third question: What benefits or consequences have resulted from the afterschool program in terms of student performance and community sentiment? Evaluation is most often equated with measuring student performance. What evaluators often see is that evaluation is actually only one piece of the puzzle, along with creating program design integrity and monitoring program fidelity. To develop your outcome evaluation, the team needs to go back to the genesis of the original plan—what were the desired student results that you envisioned? Improved academic proficiency on the state reading and mathematics assessment? More passing grades in English and mathematics classes? Improvement in acquisition of mathematics and language arts skills of the district curriculum?

Further, are there some broader outcomes that are desirable, such as community and parental support for your school and district? Student attitudes toward school? Broader participation of students in school activities? Whatever these intended outcomes may be, you have an obligation to measure their results. This obligation entails both using appropriate measurement and establishing a reasonable basis of comparison.

Evaluators speak of having valid and reliable performance measures. What they mean by *valid* is that the test instrument that you are using actually assesses the same knowledge, skill, attitude, or behavior as your stated program goal or purpose and that it is sufficiently sensitive to detect actual growth in learning. If you are trying to improve math problem-solving skills, then you actually test math problem solving. If you are trying to improve reading comprehension, you aren't testing reading fluency. What they mean by *relatable* is that it is an objective and consistent measure that will give you the same results. It isn't based on subjective judgments that can't be uniformly applied. So pick measures that are objective, relate directly to your desired outcomes, and are likely to detect actual change.

After participating for a year in the program, your test results show that students are able to demonstrate a particular level of academic proficiency. But what is your reasonable basis of comparison? Are students performing better than at the beginning of the year? Are they performing better than their counterparts who were not in the program? Are they growing at a rate more rapid than the percentile norms of the test? One way or another, you need to answer whether students are doing better. Simultaneously, you need to ask and answer: better than what? This is the standard or basis of comparison—how would students have performed *without the added benefit of the program?*

The following steps can help you organize your plan for evaluating the outcomes of your program:

- Specify the desired program outcomes (knowledge, skill, attitude, or behavior) for the intended participants.
- For each outcome, specify the instrument (test, survey, observation tool) that you will use to validly and reliably assess the participant's outcome.
- For each outcome, specify the reasonable standard of comparison to provide you with your evaluation design:

Participating student gains (pretest/posttest of participants)

Participating student mastery or proficiency rate (posttest-only attainment of a predetermined level of performance)

Participating student superiority to nonparticipating students (pretest/posttest of both participants and comparable nonparticipants to compare growth rates)

Participating student accelerated growth over test norms (pretest/posttest of participants to identify national percentile gains greater than zero)

Participating student accelerated growth over past performance (pretest, pretest, pretest/posttest of participants to see longitudinal upswing in their performance)

Participating student differential growth based on level of participation/dosage (pretest/posttest of participants compared to hours of participation in the program)

For each evaluation design, implement your assessment plan and schedule to collect performance data from your participants and others. Be sure to acquaint the staff with the process and schedule so that it is not overly intrusive or disruptive.

Develop your data analysis plan. How will you aggregate and organize the data in meaningful ways? This is *not* about inferential statistics!

COUNTS of how many participants were in the program

PERCENTAGES of how many participants achieved proficiency or positive changes

AVERAGES of the gain scores of the participants and nonparticipants

CROSS TABULATIONS showing differences by level of participation

Develop your display of results for discussion and interpretation by your team. What do these results mean? What are reasonable interpretations of their findings? Can you tell if the program is having the desired effects?

Develop the evaluation report. How do the results jibe with what you know about the program from your monitoring of implementation? What recommended actions should be taken for program improvement? What can publicly be said about program effectiveness?

Hiring a Third-Party Evaluator

A third-party evaluator is not always necessary but can provide additional objective expertise that will help steer your evaluative efforts, keep your plan on course, and teach your team to analyze data and use the results to improve the program. You should be the key voice in hiring this person, with the buy-in and input of your central office as well as key personnel from your school improvement team (including the afterschool director).

The third-party evaluator can lend ballast to work with you in a multitude of ways: shaping your program and analyzing data to inform program outcomes, and advising you and your school improvement team on data that will be helpful to you as you plan for sustainability. The following table illustrates some questions you need to ask before hiring a third-party evaluator.

The third-party evaluator, who should be expert in programs, should also apply the standards developed by the principal and afterschool staff for the afterschool program in his or her evaluation of the program. How closely does the program adhere to these standards?

Table 5.3 Hiring Your Third-Party Evaluator

Selecting a Third-Party Evaluator	Yes	To a Degree	No
1. Has the proposed evaluator worked with a program similar to your afterschool program?			
2. Does the evaluator have experience working with schools or school districts with similar demographics?			
3. Does the evaluator have experience evaluating the progress of school improvement plans?			
4. Does the evaluator have demonstrated expertise with strategies that show defects in programming?			
5. Is the evaluator skilled working as a member of a team?			
6. Does the evaluator show evidence that he or she can facilitate a team's progress as it analyzes data to shape program outcomes?			
7. Can the evaluator show solid evidence of training in evaluation?			
8. Does the evaluator belong to any professional organizations that are relevant to his or her work?			
9. Can the evaluator show a copy of a final evaluation report written for another similar project?			
10. Does the third-party evaluator have a communication plan to convey progress and results to school staff?			
11. Is the evaluator willing to help you and your team plan the program?			
12. Is the evaluator willing to report the results and discuss recommendations for improvement?			

Is there a need to modify the standards now that the program is under way? Should staffing change? Should some staff be replaced?

Finally, the evaluator needs to work with the data amassed from test scores, grades, attendance, self-reports, staff observations, and independent observations. These reports should be shared freely with all principals and afterschool staff who are involved in the program and with central office staff who are in charge of overseeing the program. While this assumes a degree of trust, it is the foundation of productive working relationships that could make the difference between sustainability of a program and a program with a very visible start and end.

Existing Evaluations: Strengths and Weaknesses

Unfortunately, there is much to critique about large-scale evaluations of afterschool programs. To date, they have been insufficient, weak, or biased by advocacy. The largest-scale and most rigorous evaluations have also been the most controversial—although their findings can be used to guide your program to successful outcomes. In this section, we review the few major, rigorous evaluations that have been conducted over the past few years.

Perhaps the largest evaluation—and the most controversial—has been the Mathematica multiyear study commissioned by the U.S. Department of Education to evaluate the 21st CCLCs. In 1999, the U.S. Department of Education selected Mathematica Policy Research, Inc., and Decision Information Resources, Inc., to evaluate the 21st CCLCs program over a three-year period of data collection. The final Mathematica evaluation was published in April 2005.

Before summarizing the Mathematica findings, it is helpful to describe the genesis and evolution of the 21st CCLCs. This program is often referred to by afterschool program advocates in almost reverential terms as the "gold standard" of afterschool/extended-day programs. It has provided a steady stream of multiyear competitive funding for afterschool programs, originally extended directly from the U.S. Department of Education, and now awarded through individual states. Since the funding has been level and substantial over the past few years, and increased almost exponentially since the 21st CCLCs began in the 1990s, it is only logical that the Department commissioned a multiyear evaluation of the 21st CCLCs.

A few sentences of additional background are helpful. The 21st CCLCs were begun by the U.S. Department of Education under the Improving America's Schools Act (IASA) in 1994. The beginning of these afterschool programs marked an unusual collaboration between the U.S. Department of Education and the Charles Stewart Mott Foundation. In 1998, the program underwent a change that expanded it from strictly afterschool programs to programs offered on weekends, holidays, and during the summer. That year also marked the requirement that programs include an academic component.

Grants were specified to last three years and awarded to local education agencies (Mathematica, 2005, p. 2). However, the academic component did not sit well with afterschool program advocates who came from community education backgrounds and believed afterschool programs should differ dramatically from regular-day schooling. And in reality, the academic focus was far from systematic, relying on "homework help," often a set of supervised worksheets completed by students.

Controversy Over Mathematica Findings

The findings of the Mathematica evaluation have not been welcomed by many advocates of afterschool programming who come from the community education perspective—a traditional approach to the afterschool hours that does not emphasize academics. The first-year findings, published in 2004, jolted the afterschool community (e.g., Afterschool Alliance, 2004). A bristling salvo of objections followed, prominently displayed on Web sites and used in talking points with policymakers. Fearful that 21st CCLC funding might diminish, afterschool advocates took aim at Mathematica's methodology, ignoring the fact that it was a randomized study—the first of its kind—and while most evaluations have flaws, it reached conclusions that were disturbing and should not be ignored.

And what were these disturbing findings? Apart from negative conclusions about academic achievement, the researchers reached a number of other discouraging, even surprising conclusions about "givens" such as feelings of safety after school.

The study examined twenty-six 21st CCLCs in twelve school districts, using a randomized controlled field trial over a two-year period of data gathering. Students at both the elementary and middle school levels were assigned to either a control group (1,050 students) or a 21st CCLC program (1,258 students) (Mathematica, 2005, p. xi).

Researchers collected data on supervision of students after school, academic achievement, student behavior, development, and feelings of safety. These data were collected from parents, teachers, students, and school records in the fall of 2000 and spring of 2001 (first follow-up), and spring of 2002 for the first student cohort, and one year later for students who applied to 21st CCLCs in the fall of 2001 (Mathematica, 2005, p. xi). The Stanford Achievement Test in reading was administered in the fall of 2000 and at the first follow-up. Program staff and principals provided implementation data; researchers visited each site twice, once during each of the two years of data collection.

Through the commissioned study, the U.S. Department of Education sought to answer three research questions:

1. Did the program improve student outcomes (safety, supervision after school, academic achievement, behavior, and social/emotional development)?

2. What types of students benefited the most?

3. What were the features and characteristics of programs? (Mathematica, 2005, p. xiii)

A long-held assertion and belief in the afterschool community—and held by the general public—is the perception that students are eager to attend afterschool programs because they provide rich experiences not provided during the regular day. However, the evaluation showed that middle school students, in particular, dropped in and out of extended-day programs (as they came to be called), considering them to be only "an acceptable place to go after school" (Mathematica, 2005, p. 24). Attendance was low or spotty at best.

Academic achievement was disappointing: on most outcomes, the researchers reported no differences between students participating in the program and those who did not. Test scores were not higher, and grades (an admittedly unreliable measure) were similar in English, mathematics, science, and social studies (Mathematica, 2005, p. xviii). Homework time, class preparation, and absenteeism during the regular day also did not differ between students who participated in the afterschool program and those who did not.

Students participating in the program did report feeling safer after school than their control group peers, but, surprisingly, were more likely to engage in negative behavior during the school day than students in the control group. This finding is of particular concern because students in the program were matched with students in

the control group, so negative behaviors cannot be blamed on differences on student demographics.

Teacher reports indicated that program students did not show evidence of improved interactions with other students; control group students showed better developmental progress. Another surprise was the researchers' finding that the program had no impact on parental involvement in school itself.

When the Mathematica evaluation findings are divided between "implementation" and "impact," they cluster as follows:

Implementation

- 21st CCLCs serve mostly low-income schools that enroll large percentages of minority students.
- Key program objectives are targeted to safety and offering activities to help students improve academically (mostly through homework help).
- Many program staff are teachers.
- Program leadership is stable, but line staff turnover is high.

The average elementary school student attends two to three days per week; the average middle school student one day per week. Middle school students attend less frequently as the year progresses and most do not return in the second year. Elementary school students attend at about the same rate throughout the year and are more likely to return in the second year (Mathematica, 2005, p. xxiii).

Impact

- Programs showed little impact on academic achievement; there was no difference between program and control groups in receiving homework assistance.
- Elementary students in the program group felt safer than those in the control group.
- The program had mixed impacts on developmental outcomes.
- Treatment-group students were more likely than control-group students to exhibit some negative behaviors. (Mathematica, 2005, xxv)

Overall, the Mathematica evaluation found that *principals* were supportive of the 21st CCLCs. According to the evaluation, approximately half helped plan the program and get it started and more than

three-fourths were advisors to it (Mathematica, 2005, p. 40). But principals tempered their involvement with realism about how much attendance in afterschool programs had increased academic achievement.

The 21st CCLC grants are three years in duration and follow the 21st CCLC maxim of a balanced program: academics, youth enrichment, and youth development.

The hypothesis that the 21st CCLCs have not been more successful in achieving their goals has cast aspersions on all afterschool programs, since the 21st CCLCs have been considered emblematic of the best afterschool programs the nation has to offer.

Yet the constant in afterschool programs—even in such a negative evaluation—has been the positive force of the principal. The fact that such a large percentage of principals have even founded programs themselves speaks to the potential of the programs and what the principal sees as their eventual value.

Other key findings of the Mathematica study were largely negative. The researchers found

- Limited academic impact
- No improvements in safety and behavior
- Negligible impact on developmental outcomes (Mathematica, 2005, pp. xii–xiii)

The evaluation also found

- Low levels of student participation
- Programs staffed predominantly by school-day teachers
- Limited efforts to form partnerships and plan for sustainability
- Cultural and interpersonal enrichment

With the exception of cultural and interpersonal enrichment, these findings were also negative—with the possible exception of the presence of classroom teachers. Principals debate whether this is desirable. Many argue that regular-day staff are exhausted by the end of their teaching and do not have sufficient energy to take on the duties of the academic component of the afterschool program, although there are exceptions.

The evaluation also pointed to student attendance as a complicating factor to program success. Students showed a pattern of dropping in and out of the afterschool program for a variety of reasons. These included taking care of siblings, enjoying other afterschool activities, preferring to "hang out" after school, and a negative attitude toward

afterschool programs, where students considered them "places to go when parents are at work" (Mathematica, 2005, pp. xvi–xvii).

The Harvard Family Research Project Evaluation Exchange

The Harvard Family Research Project has conducted many evaluations of afterschool programs, although not of their academic component. In 2005, however, the Project began to write about "complementary learning," a term they use to refer to learning that extends beyond the regular day. This promises a new focus in their evaluative work, although its extent and scope remain to be seen.

While the Mathematica evaluation remains the most famous longitudinal study of the 21 CCLCs, the Harvard Family Research Project researchers echoed Mathematica's findings in a more extensive 2005 qualitative evaluation. However, they approached them through the lens of family and community. Among the most salient are the following:

- Demographic differences affect attracting students to afterschool programs and also the number of activities in which they are willing to participate.
- Socioeconomic status and race/ethnicity affect youth's participation rates.
- Parents who encourage afterschool attendance and investment in activities are more likely to have children who participate and attend.
- Neighborhood factors predict participation in certain activities.

Family income is a strong predictor of participation, but neighborhood context continues to correlate with the activities that children select ("Complementary Learning," 2005).

These findings are worth discussion, because they obviously contain holes—yet they are the most popular focus areas of current large-scale evaluations of afterschool programs. First, afterschool programs are targeted to disadvantaged youth. Therefore, it seems almost pointless to point to neighborhood factors and familial socioeconomic factors as predictors of attendance and participation.

Second, parents who encourage children to participate in afterschool activities are more likely to have children who will do so, especially if they are able to participate themselves. The finding that centers

on students' "selection" of activities is not germane when considering the highly structured, yet engaging program you are going to have in your school. If your goal is to increase students' proficiency levels, students will not opt out of that part of the program to play volleyball instead.

RAND Adds to Mathematica Findings

A Wallace Reader's Digest Foundation–commissioned study conducted by researchers at RAND examined evidence on how to increase the positive effects of "out-of-school" time. They examined the out-of-school-time (OST) literature to clarify and contribute to the ongoing discussions in the OST community related to improving programming. Specifically, researchers Susan Bodilly and Megan Beckett focused on five major areas:

1. The level of unmet demand

2. The types of outcomes expected from OST programs

3. How quality is determined in program offerings

4. How participation is determined

5. How practices can be developed to ensure quality programming meets local demand (Bodilly & Beckett, 2005)

Afterschool advocates have pushed to increase programming and have assiduously lobbied policymakers for additional funding so that program slots can be expanded. They have done so under the operative assumption that the supply of afterschool programs does not meet the demand.

This review concluded that claims that the demand for OST programs outstrips the supply are unfounded and are based on suppositions that cannot be verified. The researchers found that advocates frequently calculated the total demand for child-care services, rather than specific OST programming, and also based this demand on surveys that did not consider alternative uses for available funds.

The study also found the existing programs had many open slots and considerable absenteeism. This confirms the findings of the Mathematica evaluation relevant to attendance and absenteeism. While the researchers did not uncover precisely what parents and students wanted from their programs, they did conclude that the exact extent of an unmet demand for OST programming is unclear.

Another component of the evaluation focused on other, existing evaluations of the outcomes of OST programs, finding a lack of rigor across these evaluations. The researchers found less than promising conclusions from the most rigorous evaluations, such as only modest positive effects on academic outcomes and antisocial behaviors such as substance abuse. *However, keep in mind that academics in afterschool programs as studied in these evaluations have been approached differently than the way they are advocated in this book.*

But the researchers did find program factors associated with positive outcomes—many of which are familiar, and these correlate with a sound school improvement plan:

- A clear mission
- High expectations
- A safe and healthy environment
- A supportive emotional climate
- Small total enrollment
- Trained personnel who remain with the program
- Appropriate content and pedagogy relative to the children's needs and the program's mission
- Integrated family and community partners
- Frequent assessment (Bodilly & Beckett, 2005)

Somewhat amazingly, these variables have not been tested in OST programs, the researchers report, but are a base of characteristics upon which program improvement efforts can be launched. They also could become yet another phase of your own ongoing evaluation.

Improving participation in afterschool programs recurs as problematic in both the Mathematica and RAND evaluations. One strategy is incentive based (see Chapter 4 for a description of an effective incentive-based afterschool program). Other strategies are more general, and use skillful communications strategies between the school, community members, afterschool staff, students, and families to communicate the goals and worth of the program. This requires, the researchers state, knowledge of what students need and how best to provide it.

The researchers warn policymakers to be skeptical of assertions that programs can meet (or should meet) multiple goals and achieve numerous outcomes. A focused, streamlined program is much more likely to succeed, they conclude. They also conclude that a large portion of resources needs to be devoted to discovering local barriers to effectiveness and strategies with which to overcome them, since local contexts vary.

Standards for Afterschool Programs

It is impossible to expect any afterschool program to be evaluated without a clear set of standards. Evaluation experts agree. However, almost nothing has been written that is research-based that defines standard setting beyond proposing myriad goals. Just as a student essay must conform to standards for essays—creativity, vocabulary, spelling, and development of an argument—so must an afterschool program have not only clear goals but benchmarks and standards that explicate those goals.

Examples might include these:

- Is academic progress viewed through multiple lenses: yours, teachers, afterschool staff, and parents?
- Are curriculum materials and pedagogy aligned with that of the regular school day? How do you know?
- Do students enter the program with a planned evaluation program that will assess their academic progress?
- Are there safeguards in place to ensure that learning will provide opportunities for students to engage with material in novel and enriching ways?
- Will students be assessed at regular, set intervals so that the data can be analyzed to improve the program, if necessary?
- What is your overall, preeminent goal for the program?
- How do you plan to ensure that you have high-quality staff who can provide engaged learning opportunities for the students who are enrolled in your program?

Evaluating your afterschool program can be—and should be—a never-ending process. One set of evaluative questions builds another; one set of responses generates another set of questions. In this way, you and your staff can refine and improve your program, discarding what doesn't work and honing what does.

Working well with a third-party evaluator can help you achieve cutoff, however, if you become too involved with the evaluative *process* and begin to lose perspective about the program itself. Just as research shows that restructuring can be a diversion from significant reform (Newmann & Associates, 1996), because staff can fixate on a particular innovation, ignoring the rest of the school day, the same can occur with evaluation of your program.

Enlist your third-party evaluator to strike a sensible point where the evaluation informs the ongoing development of your program,

but do not allow the process to impede the program itself. When in doubt, simplify the evaluation rather than complicate it.

In Chapter 6, we will discuss ways in which you can plan for the sustainability of your afterschool program—and part of that includes use of evaluation data to support your program as you continue to build a base of support for it with funders and your district.

6

Sustaining Your Afterschool Program

B y now, you have a plan for your afterschool program that includes action, monitoring, and evaluation. You have involved your school improvement team to ensure that the program does not become an afterthought—common to special programs. Instead, your plans for the program—and your careful construction of an evaluation to help keep it on track—now move you to another consideration for your program—*sustainability*.

A common pitfall for program staff who are eager to get up and running with their program is to overlook plans for sustainability until the program is about to conclude. However, planning for sustainability can't be postponed. It requires creative thought based on best practices and a team effort at the outset, just as you have done for all the other elements of your afterschool program.

But this is not a gargantuan task. Many aspects of planning to sustain your program dovetail with your evaluation plan and will mesh nicely with the results of your evaluations. One cycle of work informs the next.

Think about what it takes to sustain a program—first and foremost, successful outcomes that are recognized and valued by your community. Resources certainly. But also evidence that the program is a coherent, integral part of your school. Just as you and your staff hone your program to make it more successful, you need to consider those same refinements in the context of sustaining what you have

created. For example, if your curriculum doesn't align as neatly with that of the regular day as you had hoped, you and your team have already agreed to make midcourse or earlier changes. These are the sorts of improvements to include in your plans for sustainability.

At this point, improvements feed into sustainability. The better the program can be, the more likely it can be sustained. Rather than focusing solely on funding—a common error when planning for sustainability—it is best to construct a strategy to continue the program based on its desirability, feasibility, fidelity, and effectiveness.

Solid sustainability strategies focus on the following:

- Securing funding for the future of the program
- Maintaining or upgrading quality
- Ensuring ongoing or improved fidelity of implementation
- Drawing upon an established broad base of support from the central office, school board, community, parents, and your staff
- Using evaluation outcomes to assess best practice so that the best can continue and the rest can be discarded

Beginning Your Plan

Think back to how you created your evaluation plan. You looked ahead to what you wanted to assess and then created the mechanisms that would create the data you needed. You also considered how you would use the data—to what end—rather than generating data for data's sake. Rather than frightening your program staff with a bristling array of charts, tables, assessment tools, statistics, and randomized field trials, you and your school improvement team designed a simple yet sound plan that is easy to understand and implement.

Drawing Upon Your Base of Support

At the outset of your planning, you committed to building a broad base of support. This support, you decided in concert with your school improvement team, should come from your superintendent, your central office, your school board, your parents, key community members, business owners, and other interested stakeholders. At least quarterly, if not more frequently, you should assess your progress in building a strong base of support for your afterschool program. How well are you doing?

Table 6.1 Evaluating Impediments to Success

A. Evaluating Initial Barriers	Yes	To a Degree	No	Change Needed	Notes on Necessary Change
1. Does your afterschool staff understand how the school and/or district functions?					
2. Have you worked to establish detailed, clear job descriptions for afterschool program staff?					
3. Have you endeavored to make the afterschool program a line item in the budget?					
4. Does the school improvement team communicate the afterschool program's goals to all school staff?					
5. Has the school improvement team avoided a "drill and kill" afterschool program?					
6. What strategies are in place to connect regular-day staff and afterschool staff?					
B. Fit With School Organization	Yes	To a Degree	No	Change Needed	Notes on Necessary Change
1. Do afterschool staff understand district policies and procedures?					
2. Do afterschool staff show evidence they will work with you and other staff to avoid a "silo" program?					
3. Do afterschool staff show evidence they are qualified for the work they will do?					
4. Do afterschool staff show they understand the way the "system" works?					

(Continued)

Table 6.1 (Continued)

B. Fit With School Organization	Yes	To a Degree	No	Change Needed	Notes on Necessary Change
5. Do you have mechanisms in place so that afterschool staff and regular-day staff must meet and interact in a purposeful way?					
6. Do you solicit feedback from afterschool staff so that their sources of frustration are known and understood?					
C. Engaged Learning	Yes	To a Degree	No	Change Needed	Notes on Necessary Change
1. Have you ensured that your afterschool program's approach to student learning engages students?					
2. Can your staff easily define "engaged learning"?					
3. Have staff developed an observation protocol that helps score student engagement?					
4. If you have this protocol, do you use it during the regular school day and compare results with those from the afterschool program?					
5. If the results from your protocol are negative, do you have steps in place to immediately adjust pedagogy and curricula?					
6. Have you instilled in your entire staff that your evaluation will help your plans for program sustainability?					

Outreach to Community Members

Reaching out to your community is also critical to building a network of support for your program. Of course you want to include parents of students in your afterschool program as a vital source of links to other parents and families within your school community. But your community as a whole is also precious. If it supports your efforts, approves of your goals, and applauds your outcomes, your odds of sustaining your program are greatly enhanced.

Key among your community members are school board members, local businesspeople, the mayor, civic board and commission members, community agencies serving youth, and anyone else who could be a source of support, ideas, or potential funding. If your district has a development officer, the initial planning stage is the time to involve this individual.

Have specific ideas about ways in which to engage these people. Respect their busy schedules. Understand that what may work for a businessperson may not work for a community agency director.

Looking Close to Home for Funds

Funding is a critical part of sustainability planning. It is a piece of your outreach plan, particularly when building goodwill community-wide, when thinking about how parents, key community members, sympathetic board members, supportive central office staff, a committed superintendent, and members of your own staff can join to build an almost impenetrable web of support for your program.

Key among these stakeholders are businesspeople and civic leaders. These are individuals who may have substantial amounts of money that they invest in local programs or charities, or they may make only modest contributions. Whether their financial means are large or small, all should be aware of your program and invested in its success.

This is a delicate area where you should do three things:

1. Discuss it with your superintendent, who is better connected in the community than you are.

2. Defer to your development officer, if your district has one.

3. Participate as much as possible in civic groups, such as Rotary, Lions Club, Library Board, or other boards and commissions that do not present a conflict of interest.

Table 6.2 Building Your Base of Support

A. Building Support With the Central Office and Board	Yes	To a Degree	No	Change Needed	Notes on Necessary Change
1. Do you meet regularly with your superintendent to discuss program progress and success?					
2. Do you share data with your superintendent?					
3. Do you candidly discuss areas where improvement is planned?					
4. Do you seek your superintendent's input?					
5. Do you take that input back to your school improvement team for discussion/action?					
6. Do you close the loop with your superintendent by telling him or her the results of your meeting with your team about that input?					
7. Do you invite your superintendent to visit the program, perhaps with a school board member?					
8. Do you meet at regular intervals with key central office staff (e.g., Title I director, school improvement director, curriculum/instruction direction, grant writer [if applicable], public relations director [if applicable])					
9. Do you share data with central office personnel?					
10. Are you open about program progress and challenges?					
11. Do you take central office feedback back to your team for discussion/action?					
12. Do you communicate the results of that discussion/action with central office staff?					
13. Do you urge central office personnel to visit the program?					
14. Do you encourage these personnel to join in nonevaluative interactions with program staff and students?					

B. Parent Outreach	Yes	To a Degree	No	Change Needed	Notes on Necessary Change
1. Do your regular-day and afterschool staff reach out to parents to invite them into the afterschool program?					
2. If parents visit the program, have staff made provisions so that parents are welcomed immediately?					
3. Do parents have a menu of choices about roles they can fill in the program?					
4. If parents do not or cannot fill a specific role, are they welcome to fill a general function for the program when they can, under supervision?					
5. Are parents' cultural heritages and languages, if other than English, honored and celebrated in the classroom?					
6. Are there arrangements for parents to participate and thus learn in the academic content portion of the program, if they want to?					
7. Are there "fun" ways parents can interact with program staff and students, such as arranging a potluck supper or an event outside afterschool hours?					
8. Are notices about the program disseminated in a variety of forms?					
9. Can parents "tell the story" of the afterschool program to other families?					
10. Are parents represented on the school improvement team?					

Table 6.3 Building Community-Based Support

A. Working With Community Leaders	Yes	To a Degree	No	Change Needed	Notes on Necessary Change
1. Do you have a specific plan and time line for ways in which you can connect with community leaders?					
2. Do you know the best ways to reach community leaders and share news of your afterschool program?					
3. Are you able to evaluate whether phone calls, breakfasts, lunches, or "drop-by" visits are the most effective communication strategy?					
4. Do you make it a point to have a specific agenda when you talk to community leaders?					
5. Do you schedule your contact time to respect community leaders' busy schedules?					
6. Have you researched the most effective ways to build a relationship with community leaders?					
7. Do you ask questions as well as present information?					
8. Do you listen carefully to community leaders when they talk about your program and your school?					
9. Do you take community leaders' comments back to your afterschool staff and your school improvement team for discussion and action, if warranted?					
10. Do you invite community leaders to visit the program and follow up with them?					
11. Do you invite community leaders to volunteer in the program?					
12. Do you ensure that your school improvement team welcomes community leaders during the school day and afterschool hours?					

B. Involving Community Agencies	Yes	To a Degree	No	Change Needed	Notes on Necessary Change
1. Do you and your afterschool staff know key members of youth community agencies?					
2. Do you and your afterschool staff meet regularly with youth community agency staff to communicate your afterschool program news and progress?					
3. Do you regard your community agency staff as a key source of advice on involving parents and family members?					
4. Do you ensure that at least one community agency staff member is represented on your school improvement team?					
5. Do you communicate news of your goals, implementation, and outcomes regularly to community agency staff?					
6. Do you regularly ascertain whether community agency staff are aligned with the program's goals, particularly your focus on academics?					
7. Do you try to find out reasons that community agency staff may not agree with your goals for academic achievement, and then seek common ground?					
8. Wherever possible, do you seek to involve community agency staff in your program, if they are congruent with your goals and implementation?					

The latter strategy is good for you overall. It connects you widely to the community. You make important contacts for yourself, your school, and your district. You easily can be pegged as a "go-getter" and be favorably regarded within the broader base of your town or city.

Be careful not to overextend yourself, however. Volunteering to serve on a committee is an excellent idea, if aligned with your expertise or a particular passion. Volunteering to serve on several committees spreads you too thin and can label you as overly ambitious. If you are a newcomer, you have to put in your time learning the ropes, doing a lot of active listening, asking questions when things aren't clear, and mixing well in large and small groups. The last thing you or your superintendent wants is the perception that you are fundraising for a special program, a maverick operating in isolation from the district's plan. That is why you must have the support of your superintendent and as many board members as possible. And since you are not a professional fundraiser, it is best to defer to those who are, while doing your research in the event you and your team—or selected members of your team—are going to write proposals for funding.

Securing Continued Funding

In one district I visited, the superintendent commented bluntly on sustainability. When I asked how he felt about the current grant ending in two years (it was a three-year grant), he snorted and said, "I always tell them: Enjoy the three years!"

While you may hope this is an unusual attitude, it isn't if a base of support hasn't been constructed during the planning stage for sustaining the program. Why would a superintendent or board member go to bat for a program he or she knows little about or that has proven itself to be unsuccessful? Why would anyone? If the only people in your school who like your program are the people who work in the program, does that tell you anything—evaluation aside?

The best picture is that your superintendent and board are committed to your program. If you are grant-funded, as is likely, they have joined with you to work on a budget for your program to continue. It may be a core budget only, and they may expect you to match it through other money.

Another scenario, and a likely one, is that you may have their support—and never underestimate its importance—but they expect you to find the money. In this day of scarce resources, when excellent programs and staff are pitted against each other to justify and maintain their existence, this is a common scenario. One of your tasks is to

follow through and find funding. Another task is to ensure that this scenario does not jettison your program.

Find the Money and Braid the Resources

At the outset of your planning, you constructed a budget. You and your team worked hard to make sure it was realistic, tilting the majority of your resources into hiring highly qualified staff, ensuring that curricula and resources matched those provided during the regular day, and built in provisions for solid professional development.

Each year your program has continued, you have made changes to the budget to adjust for inflation, for staff changes, for an initial investment in curriculum materials that has been minimized as the program progresses, and so on. If your grant extends for three years, at the end of the first year and a half you should be able to project what you will need at the end of year three.

How will you get it? If you already know there will be no money— or scant funds—coming from your district budget, you can't begin to plan your grant writing too quickly. Research, research, research. Afterschool programs are a very hot topic. The 21st CCLCs alone have been level-funded at nearly $1 billion since 2002.

Perhaps you already have 21st CCLC money, and need to look elsewhere. Creativity, creativity, creativity. A wide variety of foundations fund afterschool programs. Community agencies put in dollars, too. Community donors often open their pockets at the prospect of funding a good program serving youth that is close to home. Community donors and businesspeople may find it particularly persuasive if they realize that a better-educated student will reduce the eventual burden on society and has an improved chance of entering the workforce.

Are your staff working as hard as they might on the program's sustainability? Perhaps they need a reminder that their jobs and the program are synonymous. Often there is a curious phenomenon that occurs when staff live on soft money. Denial. Frequently they reason that somehow, magically, their program will be saved. They don't know exactly how, but they calculate that the program is so good, someone will intervene to rescue it. As the days drift by without any sign of divine intervention, staff become bitter, alienated from the program, and angry with their superiors.

If, however, they had been on board working to find funding opportunities—even if not skilled at proposal writing—they could play a part in funding sustainability for their program. If the program fails

to secure funding, they have been a part of that failure. It is not something that *happened to them;* they have been involved in the process.

If your district has a professional grant writer, that individual also knows of grant competitions and has grant-writing expertise. Watch for Requests for Proposals (RFPs) from funding agencies. Be sure to schedule the grant writer's time as far in advance as possible; district grant writers are usually overburdened and feel underappreciated as well. Make the grant writer your friend as well as your colleague. Engage him or her as early as possible in communicating your goals, the results of your implementation, and your outcomes. Be frank about where you need to improve—and what you want to do in Stage Two.

If you do not have the luxury of a professional grant writer, buck up. It's your turn to take up the challenge. While it is difficult to write by consensus, it is the only way to write a successful grant proposal. Form a council (you probably have enough committees at this point) that will concentrate on the specific grant at hand. Go into the meeting with an agenda and specific responsibilities for each individual so that you don't spend your time wandering or musing about whether this is the direction you want to take. Remember, your time to turn around a grant is limited. And remember: deadlines, deadlines, deadlines.

If someone on the council absolutely does not want to participate in the grant-writing process or shows no enthusiasm, dismiss the person and engage another person who is more enthusiastic about your plans. A winning proposal is one that is written from the heart. All the data in the world will not convince a funding agency if your proposal is bloodless, detached, and dull.

Dissect the RFP. Have a wide-ranging discussion about it. Disseminate the RFP in advance so that council members can come to the table prepared, having read it at least once (three times is preferable). Again, if you see signs that members haven't read the RFP, this is the time for them to move on to other responsibilities and to replace them with other staff.

From your analysis of the RFP, decide on the main themes and how you will address them individually and collectively. Determine writing assignments and deadlines. Backward map from the date the proposal is due at the funding agency to the date of the first draft. Assign the next meeting date.

When people leave the room, they should be crystal clear on their individual responsibilities, their deadlines, and the focus of the grant. If they have questions that have lingered after the meeting, you should be prepared to answer them, but a well-prepared meeting should have taken care of lingering questions.

Rely on technology to speed the process along. E-mail is a great connector, and it is fast. E-mail drafts to each other. Set deadlines for feedback.

Ensure quality control. At the time of your final draft, send it to your school improvement team, your superintendent, and a school board member. Be careful not to get too much input; that can bog down the entire process and offend reviewers if you do not incorporate some of their suggestions. But a broader base than your proposal-writing team helps ensure clarity, focus, and fidelity. The review team should read your proposal against the RFP with a critical eye. Does the proposal speak to what the RFP wants? Does it provide too much information that is unrelated? Is it focused and sharp? Does it have a heart? Is it supported with data?

Don't stop here. Write another proposal, and another. You will find you will become better and better at this the more you do it, and your skills will be sharpened. The worst that can happen is that you will be funded for everything—and then you enlarge your plan, involve more students, and hire more staff. Or else you return to the funder and include more schools. Or, you plan to do that in the subsequent proposals that you write. Many successful afterschool program proposals have been written for constellations of schools in the same district, and the money allocated to the individual schools.

Table 6.4 Seeking Continued Funding for Your Program

A. Presence in the Community	Yes	To a Degree	No	Change Needed	Notes on Necessary Change
1. Have you made a strong effort to ensure that your superintendent knows that you are visible in the community and that you promote not only what occurs during your regular day but also your afterschool program?					
2. Do you belong to and participate in at least one civic group?					
3. Is your goal as a member of a civic group to network and increase public knowledge of your school and district?					
4. Do you sincerely believe that friendly, unpressured contacts are key to the sustained presence of your program?					
5. Do you oversee your staff's community work to make sure it is purposeful, not scattered, and not duplicative?					
6. Does your staff tell you about their community contacts so that you can build a broad base of support in tandem with them?					
7. Do you make it a rule to never take your superintendent by surprise?					
8. Do you have regular contacts with your district's development officer (if applicable), and feel confident that he or she understands your afterschool program?					
9. Do you meet regularly with your district's grant writer (if applicable), and communicate your needs for sustainability of your program?					
B. Seeking Funding	Yes	To a Degree	No	Change Needed	Notes on Necessary Change
1. Is your team familiar with your afterschool budget?					
2. Are you committed to finding outside funding if district funds are unavailable?					
3. Have you involved your development officer (if applicable) and grant writer (if applicable) in your discussions of sustainability?					

B. Seeking Funding	Yes	To a Degree	No	Change Needed	Notes on Necessary Change
4. Have you formed a proposal development council for your program if you do not have a grant writer and/or development officer?					
5. Does each staff member on your council take responsibility for the sustainability of the program?					
6. Do council members understand that they must contribute to the proposal or proposals in order to remain on the council?					
7. Do you set clear agendas for council meetings, complete with deadlines?					
8. Do you replace recalcitrant members at the outset and communicate that you will do so?					
9. Have you secured your superintendent's willingness to review your final draft in advance?					
10. Have you made sure that your school improvement team expects to review the proposal as part of its work?					
11. Have you established concrete procedures to ensure quality?					
12. Do you work with your proposal team to ensure that they write "with a heart" and back their plans with data?					
13. Do you welcome comments from your reviewers because they will strengthen your proposal?					
14. Have you limited your reviewers to a manageable group so that you can deal with comments— and have you ensured they are people whose comments you will respect?					

Conclusion

There is never sufficient time in the day, nor resources in your account, to do it all. But from the lessons learned in these chapters and your own experience as a principal, there is always just enough to do what is really important. You have helped plan an effective afterschool program. Without a doubt, there will be other priorities and demands on your attention tomorrow and next week and next year. But you can shift your focus to these other issues with the confidence that the afterschool program has a solid foundation and will continue to benefit students and the community for many years to come.

Resources for Afterschool Programs

The Afterschool Alliance

www.afterschoolalliance.org

The Afterschool Alliance is a nonprofit organization that works to raise awareness of the importance of afterschool programs. In that capacity, it advocates high-quality, affordable afterschool programs for all children. The Alliance's Web site has numerous tools and tips on accessing funding, achieving sustainability, and using communications to build support for programs among local residents, community groups, businesses, and policymakers.

American Association of School Administrators (AASA)

www.aasa.org

AASA has developed *a toolkit for school leaders that contains* resources that school leaders and staff can use to plan, implement, and sustain quality afterschool programs.

Communities in Schools After-School Program Toolkit

www.cisnet.org/working_together/after-school.asp

The nation's fifth largest youth-serving organization, Communities in Schools (CIS) champions the connection of needed community resources with schools to help youth succeed in school and prepare for life. During the 2004–2005 school year, more than 1,300 education sites served by CIS offered after- or before-school programming.

Communities in Schools provides an afterschool program toolkit summarizing effective afterschool programs, a checklist of the core elements that contribute to the success of these programs, resources to sustain quality afterschool programs, elements associated with afterschool programs that promote reading and mathematics skills, and other resources to sustain solid afterschool programs.

Council of Chief State School Officers (CCSO) Extended Learning Opportunities

www.ccsso.org/Projects/Extended_Learning_Opportunities/

The Council of Chief State School Officers (CCSSO) has been actively engaged in research and development activities to gain knowledge about extended learning and development opportunities. It also works to build state capacity in the implementation and maintenance of these programs. The Council has developed profiles of exemplary afterschool and summer programs that have demonstrated positive outcomes for students attending high-poverty schools, in order to highlight effective practices as well as state and local policies that support these programs. The Council of Chief State School Officers also provides support and technical assistance to state education agencies focused on implementing key federal programs authorized as part of the No Child Left Behind Act, including the 21st Century Community Learning Centers (21st CCLCs) and Supplemental Educational Services.

The Finance Project's Out-of-School Time Clearinghouse

www.financeproject.org/irc/ost.asp

The Finance Project's resources help leaders address financing and sustainability issues for out-of-school time programs. The Out-of-School Time Clearinghouse brings together the Finance Project's resources with resources developed by other organizations dedicated to building better afterschool programs. Resources included in the Clearinghouse cover topics such as funding, data for decision making, developing partnerships, mobilizing communities, measuring and using results, planning for sustainability, profiles of successful sustainability strategies, and links to partner organizations.

Harvard Family Research Project (HFRP)

www.gse.harvard.edu/hfrp/projects/afterschool/resources/index.html

The HFRP Out-of-School Time Learning and Development Project has a searchable online database of narrative profiles of out-of-school

time (OST) evaluations and research studies. The Web site also has an OST evaluation bibliography and a series of briefs on evaluation. Topics in the series of briefs include the role of youth as researchers, state strategies and investments in OST evaluation, implementation issues, and OST outcomes.

Mid-continent Research for Education and Learning (McREL)

www.mcrel.org

McREL has several publications on afterschool effectiveness and practice. The most pertinent to academic achievement in afterschool programs include *The Effectiveness of Out-of-School Time Strategies in Assisting Low-achieving Students in Reading and Mathematics: A Research Synthesis* and *Afterschool Mathematics Practices: A Review of Supporting Literature.*

The Charles Stewart Mott Foundation

www.mott.org

The Charles Stewart Mott Foundation, arguably the most influential foundation in the afterschool community, maintains current news about afterschool programs as well as lists of grants and grantee profiles on its Web site. This resource can be consulted to gain a sense of what direction a grant seeker might take in order to be successfully funded. The Mott Foundation's grant making is diversified to reflect the Foundation's interest in technical assistance, research, evaluation, and policy development.

National Association of Elementary School Principals (NAESP)

www.naesp.org

The NAESP Web site has a section devoted to afterschool programs that lists research articles, tips for starting an afterschool program, case studies, and other articles that showcase successful components of afterschool programs.

National Institute on Out-of-School Time (NIOST)

www.niost.org

The National Institute on Out-of-School Time at Wellesley College is an action research institute providing a national perspective on the

critical issues facing the OST field. NIOST has conducted, interpreted, and synthesized research for policymakers, the media, and practitioners. Research and other resources are available on their Web site.

National Partnership for Quality Afterschool Learning

www.sedl/afterschool/.org

The National Partnership for Quality Afterschool Learning helps state education agencies and local practitioners develop high-quality, balanced programs that provide a safe and enjoyable environment for academic enrichment as well as youth development activities. The Web site has many resources that include a *Resource Guide for Planning and Operating Afterschool Programs: The Afterschool Training Toolkit*, which includes promising practices and sample lessons in arts, literacy, math, science, technology, and homework help; and a *Literacy in Afterschool Programs Literature Review.*

National School Boards Association

www.nsba.org

This Web site is a clearinghouse of information for school board leaders to build and sustain extended learning opportunities for all students. This Web site contains research, tools, and information on afterschool programs and school-community partnerships. One tool on sustainability is *Building and Sustaining After School Programs: Successful Practices in School Board Leadership.*

Policy Studies Associates Resources on Youth Development/After-School Programs

www.policystudies.com/studies/indexyouth.html

The Policy Studies Associates have made the evaluation of afterschool programs a major focus. Their site lists several research studies on the sustainability of programs, shared features of high-performing programs, and evaluations of programs across the country.

RAND Corporation

www.rand.org

The RAND Corporation has conducted studies on afterschool programs, including the empirical *Making Out-of-School-Time Matter: Evidence for an Action Agenda*, available on its Web site.

21st Century Community Learning Centers

www.ed.gov/programs/21stcclc/index.html

The 21st Century Community Learning Centers is the preeminent source of funding for afterschool programs in the nation. It supports the creation of community learning centers that provide academic enrichment opportunities for children, particularly students who attend high-poverty and low-performing schools. The program helps students meet state and local student standards in core academic subjects, such as reading and math; offers students a broad array of enrichment activities that can complement their regular academic programs; and offers literacy and other educational services to the families of participating children.

Wallace Foundation Knowledge Center

www.wallacefoundation.org/KnowledgeCenter/KnowledgeTopics/Out-Of-SchoolLearning/

The Wallace Foundation has many resources and research reviews on using public and private resources effectively to develop and sustain high-quality OST learning programs. Reports include a review of available evidence on the cost of OST programs, how to increase family involvement in afterschool services, and how policymakers and program providers can plan for broad, lasting improvements in OST services.

William T. Grant Foundation

www.wtgrantfoundation.org

The William T. Grant Foundation focuses on supporting research to improve the lives of youth ages 8 to 25 in the United States by investing in high-quality empirical studies. Current research priorities are focused on understanding and improving social settings (e.g., families, schools, peer groups, organizations, and programs), their effects on youth, and the use and influence of scientific evidence. The current "action topic" is improving the quality of afterschool programs.

References

Afterschool Alliance. (2004, October 7). *Afterschool Advocate, 5*(11) [Newsletter]. Washington, DC: Author.

Barkley, S., Bottoms, G., Feagin, C., & Clark, S. (2001). *Leadership matters: Building leadership capacity.* Atlanta, GA: Southern Regional Educational Board.

Bodilly, S., & Beckett, M. (2005). *Making out-of-school time matter: Evidence for an action agenda.* Santa Monica, CA: RAND.

Britsch, B., Martin, N., Stuczynski, A., Tomala, B., & Tucci, P. (2005). *Literacy in afterschool programs: Literature review.* Austin, TX: Southeast Educational Development Laboratory and Portland, OR: Northwest Regional Educational Laboratory.

Complementary learning. (2005). *Harvard Family Research Project, 11*(1).

Deal, T., & Peterson, K. D. (2003). *Shaping school culture.* San Francisco: Jossey-Bass.

Fashola, O. S. (2002). *Building effective afterschool programs.* Thousand Oaks, CA: Corwin Press.

Gordon, E. W., Bridglall, B. L., & Meroe, A. S. (2005). *Supplementary education: The hidden curriculum of high academic achievement.* Lanham, MD: Rowman & Littlefield.

Lockwood, A. T. (1997). *Conversations with educational leaders.* Albany: State University of New York Press.

Lockwood, A. T. (2003a). *Interim report to the C. S. Mott Foundation.* Arlington, VA: American Association of School Administrators.

Lockwood, A. T. (2003b, August). It's not just bureaucratic barriers. *The School Administrator.*

Manzo, K. K. (2006, March 8). Demand to add academics to after-school care grows. *Education Week, 25*(26), 7.

Mathematica Policy Research. (2005). *When schools stay open late: The national evaluation of the 21st Century Community Learning Centers Program. Final Report.* Washington, DC: Institute of Education Sciences, U.S. Department of Education.

MetLife. (2003). *The MetLife survey of the American teacher: An examination of school leadership.* Retrieved July 27, 2005, from www.metlife.com/WPS Assets/20781259951075837470V1F2003%20Survey.pdf

National Association of Elementary School Principals. (2001). *Principals and after-school programs: A survey of PreK–8 principals.* Reston, VA: Author.

National Association of Elementary School Principals. (2005). *Trends in education statistics.* Reston, VA: Author.

National Center for Education Statistics. (2006, February). *Trends in school district demographics: 1986–87 to 1990–91.* Washington, DC: U.S. Department of Education.

Nelson, S. (1986). *How healthy is your school? Guidelines for evaluating school health promotion.* Reston, VA: NCHE Press.

Newmann, F. M. (1992). *Student engagement and achievement in American secondary schools.* New York: Teachers College Press.

Newmann, F. M., & Associates. (1996). *Authentic achievement: Restructuring schools for intellectual quality.* San Francisco: Jossey-Bass.

NIOST. (n.d.). *Workshop: Afterschool programs. From vision to reality.* Thirteen Ed Online: Concept to Classroom. Retrieved July 2005 from www.thirteen .org/edonline/concept2class/afterschool/implementation.html

Public Agenda. (2004). *All work and no play? Listening to what kids and parents really want from out-of-school time.* New York: Author.

Schneider, E. J., & Hollenczer, L. L. (2005). *The principal's guide to managing communication.* Thousand Oaks, CA: Corwin Press.

Sizer, T. R. (1984). *Horace's compromise: The dilemma of the American high school.* Boston: Houghton Mifflin.

U.S. Department of Education. (2002, June 18). *21st Century Community Learning Centers Program honored with public service award.* Retrieved July 2005 from www.ed.gov/news/pressreleases/2002/06/06182002 .html

U.S. Department of Education. (2003, May 13). *Testimony by Deputy Education Secretary Hansen on 21st Century Community Learning Centers.* Retrieved July 2005 from www.ed.gov/news/pressreleases/2003/05/05132003a .html

U.S. Department of Education. (n.d.a). *21st Century Community Learning Centers.* Retrieved July 2005 from www.ed.gov/programs/21stcclc/ index.html

U.S. Department of Education (n.d.b). *Answers.* Retrieved July 2005 from http://answers.ed.gov/

U.S. Department of Education (n.d.c). *Policy: Elementary and secondary education.* Retrieved July 2005 from www.ed.gov/policy/elsec/leg/esea02/index .html

Index